IMAGES
of America

THE MOJAVE
DESERT

IMAGES
of America

THE MOJAVE
DESERT

John M. Swisher

ARCADIA

First Printed 1999.
Reprinted 2001.

Published by Arcadia Publishing,
an imprint of Tempus Publishing, Inc.
3047 N. Lincoln Ave., Suite 410
Chicago, IL 60657

Printed in Great Britain.

Library of Congress Catalog Card Number: 99-65564

For all general information contact Arcadia Publishing at:
Telephone 843-853-2070
Fax 843-853-0044
E-Mail sales@arcadiapublishing.com

For customer service and orders:
Toll-Free 1-888-313-2665

Visit us on the internet at http://www.arcadiapublishing.com

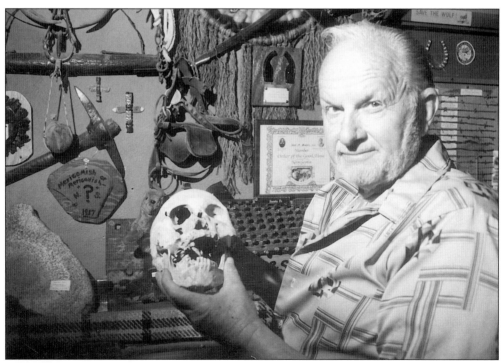

"Miss Aleutian Isle of 1044 A.D." While excavating a 1940s U.S. Naval archeological site at Dutch Harbor, AL, the author (seen here) unearthed a human female skull. Her teeth required studying and she was taken from the area for that purpose. Four decades later the author returned her to the spot she was originally buried at some 800 years earlier. R.I.P.

CONTENTS

INTRODUCTION

The name "Mojave" derives from the Mojave Indian word "aha macava." Spelled 50 different ways by outsiders, "Mohave," "Mohahve," and "A mac ha ves" are but a few of the non-native spellings. To fill the void of that tribe not having a written language over a century ago, strangers resorted to phonics in their communication. The Mojaves, a powerful, aggressive group, still reside near Needles, CA, and once ranged over much of the desert.

Around 1900 the United States Geographic Board secured "Mohave" as the legal name for these 15,000 square miles, 33 times larger than Los Angeles. Rising from below sea level, this thirsty expanse climbs to over 4,000 feet. More than 3,500 different forms of wildlife make homes among the over 1,300 known aboriginal plants. Through the years, daily use of the word Mohave has been changed by Californians, who mostly drop the "h" and substitute a "j." Mojave has also become the official spelling used today by this Needles/Colorado River tribe. A massive, parched region, its name has been heated and hammered and whittled from nature's subterranean blast furnace coupled with the unpitying anvils of time to forge this vast land.

Three months before the 1776 signing of the Declaration of Independence at Philadelphia, a Spanish padre passed through the Mojave Desert. He was the first non-native known to have visited this land of mineral wealth, eerie beauty, and countless contrasts. Wedge shaped, it rolls eastward from the Antelope Valley to beyond the Colorado River. Rainfall usually varies from about 5 to 10 inches a year, with summer heat well above 130 degrees. The highest temperature ever recorded in the United States occurred here. Freezing winters are usually shrouded in ice and snow. The elevation is between less than sea level to several thousand feet, not counting mountain tops. Once both a Spanish and Mexican possession, the Mojave Desert joined the Union of the United States on September 5, 1850, and became part of the new San Bernardino County three years later. Prior to becoming a part of San Bernardino County, "Mojave" was in Los Angeles County. A sleepy growth area for many years, the Mojave has, within two decades, become a stronghold for desert-devoted recreational opportunities. The California Desert Protection Act became law on October 31, 1994. This legislation converted 1.6 million acres into the Mojave National Preserve, located within the heart of the extended Mojave Desert. Now, please peek inside these pages, and you'll find out why my land, "The Mojave," is quickly gaining the reputation of being one of the leading golden opportunity bases for America's present and exciting future.

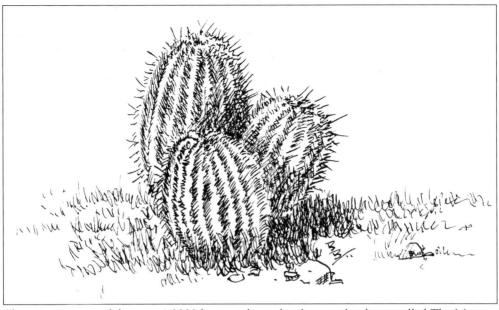

This cactus is one of the over 1,3000 known plants that live on the desert called The Mojave.

DEDICATION

This Mojave Desert pictorial history is dedicated to our desert's very own master oil painter. "B.B." Cowboy Bill Bender was born in the midst of a worldwide influenza epidemic in 1918. His teen years were largely baled together by hungry horses he rounded up at the Los Angeles Stockyard. Then he would tutor these unbroken "skins," taming and training them as saddle ponies for horse-starved folks. Graduating from El Sugundo High School, Bill mounted one horse, trailed another, and rode through the Los Angeles basin heading for the tiny 1930 village of Bishop, CA. Once there, Bill was engaged on a three-year junket, packing horses through the High Sierras for outdoor enthusiasts. The urge to ride on came, so B.B. dreamed up an extended horseback ride all the way north to Canada. Once there, the lure to head south pulled him and his mustangs into Mexican scenes, old Mexico. These sightseeing pilgrimages added immensely to Bender's already great love for nature's beauty and understanding of its whims.

Similar to most of John Muir's wanderings, Bill, too, rode alone—seeing, touching, and feeling the real out-of-doors in depth. Injured in a horse mishap, he was idled for a spell. He recovered sufficiently enough to again slip aboard a range horse and spur $30 a month and grub from a cattle-filled cowboy's life. One added inducement pulling on Bender's new vocation was having blue skies as a roof over his head every night in all kinds of Mojave Desert weather. With his chores done, Hollywood's thirst for horse-savvy western movie extras changed his arena, and he became a stuntman in shoot-'em-up pictures. Then came 1955, the year Disneyland Theme Park opened, and cowboy Bill gained stature as an illustrator/painter/artist. During these

years, a major greeting card company, the Leaning Tree, tied Bender to their world famous stable of outstanding artists blessed with a gifted touch with brushes on canvas. His own paint brush characteristics are quite recognizable, as is his autograph—"B.B." Besides generating spine tingling desert landscapes, B.B.'s harmless, funny bone humor achievements became a "must have" greeting card for all occasions.

Now in his 80s, Cowboy Bill first became branded by the Mojave Desert in the 1920s. Within a decade, he thoroughly felt at home with Joshuas, jumping cactus, rattlesnakes, and using a worn saddle for his pillow. His efforts in many fields have, without a doubt, enriched the Mojave Region and the great Southwest. One unheralded talent Bill exports is his honest friendship toward everyone. Always a gentleman, Cowboy Bill is a soft-spoken, quick-to-smile fellow who year after year has truly made life on the harsh ol' Mojave better and far more amusing. Helen, his lovely wife, shows her pride for her man with spirited eyes, flashing sincerely on this person so blessed with kindness and helpfulness for all.

Thank you Bill for all you've become, for all you've done and, most of all, for being here with the rest of us "desert rats." Even when the pickings were slim and dusty trails rode hard, you came through brightly.

We salute you!

One

DESERT PEOPLE
AND THEIR CASTLES

Almost all American travelers have heard of Death Valley Scotty's fabulous castle, located at the north end of that valley. Legend says that Death Valley Scotty prospected here and hit a true glory hole. Having more money than he could use, Scotty supposedly had this lush edifice constructed at a small oasis he knew. The multi-storied cement structure's cost amounted to more than $2 million in 1931 (Depression time). Factually, Scotty never had a mine but lived and played off of his friends, Mr. and Mrs. A.M. Johnson, Chicago financiers. (Courtesy Gill Brewer.)

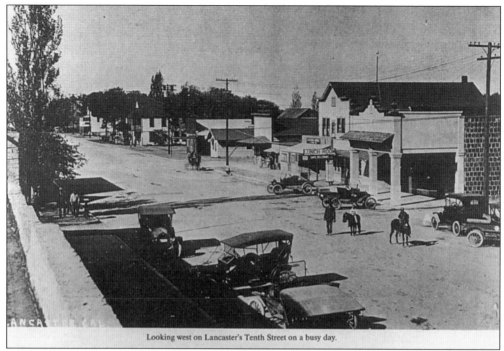

Looking west on Lancaster's Tenth Street on a busy day.

Appearing to have been a posed photograph, this 1914 picture carries the notation of having been taken on a busy day, Note how the autos were parked in those times. (Courtesy City of Lancaster Museum & Art Gallery.)

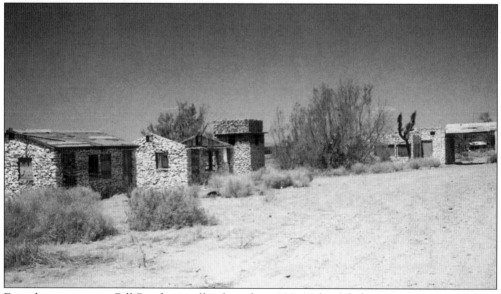

Famed western artist Bill Bender recalls when this 1930s Helendale business on Route 66 sold oil and gasoline, did repair work on vehicles, and rented tourist cabins. Lemonade was also vended to thirsty travelers here, and Union Oil products were available. Bill and Alice Potopov, owners, farmed a little along the Santa Fe train tracks. They built a barn and water tank tower as seen in this picture. Bill says he can not remember what happened to the lemonade stand, but its cement slab is still there.

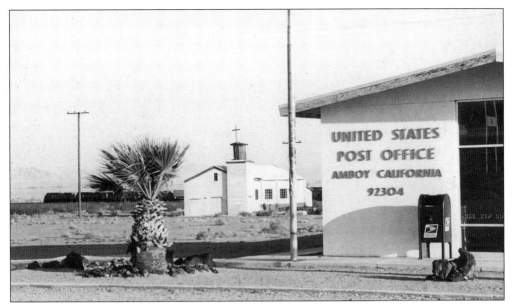

The sleepy little whistle stop of Amboy was once very much alive and growing. When Route 66 bypassed here, things changed for the worst. Founded in 1858, the 1999 posted population boasted 20 residents. Once, Amboy had a Santa Fe train station and a population of over 500 people. The good times here halted in 1972, when Interstate 40 opened and the Mojave Desert's Amboy returned to producing creosote bushes and scrub brush.

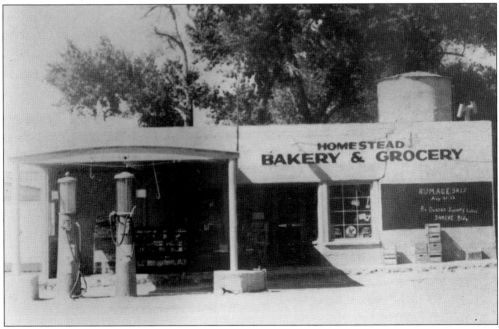

From 1927 to 1957, this building housed the Homestead Bakery and Grocery Store. Located on Lucerne Valley's Box "S" Ranch property, it is still in use. Used furniture is now sold here. The gasoline pumps seen in this picture, like twin-jeweled pinnacles, disappeared years ago. Once considered of no value, these aged pumps are selling at high prices in antique shops. (Courtesy Charles Rader.)

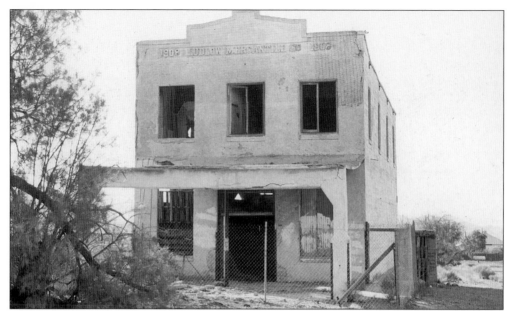

The Ludlow Mercantile Company, shown here, was owned by Matilda "Maw" Preston. She arrived in Ludlow in 1906 and erected her store two years later. Selling general goods, she also rented rooms and operated a cafe. Maw had no competition until 1917, when Tom Murphy came to town and opened a similar store. (Courtesy Gill Brewer.)

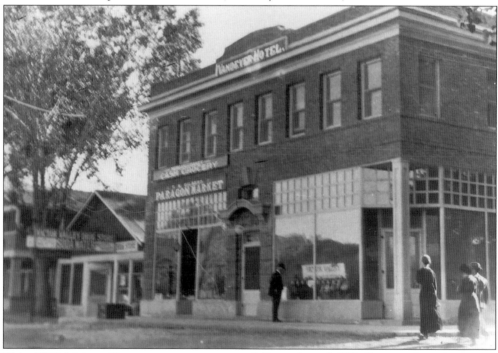

This 1915 Mojave Desert street scene was of Seventh and "D" Streets, then downtown Victorville. Note the women's long dresses dusting along on the dirt roadway. This picture was returned to Victor Valley in 1996 by a member of the Overholt family, original homesteaders in Apple Valley. (Courtesy Overholt Collection.)

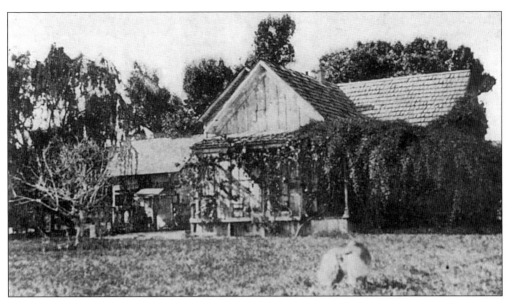

The Robert Turner Ranch home in Victorville is seen here in 1914. Turner's was also called "the Spring Ranch," as it had numerous water springs in the vicinity. The ranch was one of the largest in the 1900s effort to tame the Mojave Desert and turn Victor Valley green. Robert Turner passed on in 1916, and for many years, the Turner family was responsible for making Victorville famous and prosperous. Robert's collie was photographed on some of the then 40-acre property. (Courtesy *Kingdom of the Sun*.)

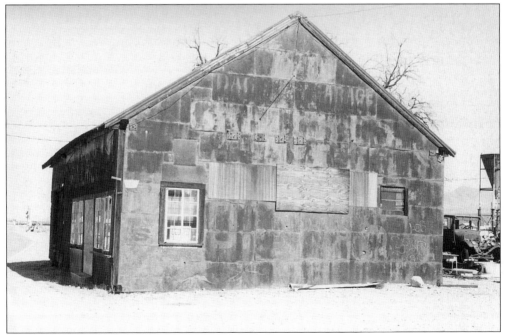

Called the Daggett Garage for years, this building was also known as the Fouts Building. Once used as a railroad roundhouse, it has been a livery stable, a gasoline buggy station, and a grocery store with a dirt floor. In the mid-1940s, an automobile fix-it shop, which also did blacksmith work, was located here. This Daggett photograph was taken in 1999. (Courtesy Gill Brewer.)

The Mojave's first African-American guest "dude" ranch was located in Apple Valley. Called the Murray Ranch, it was noted for its fine food, hospitality, and celebrities like boxer Joe "Brown Bomber" Louis. Singer Pearl Bailey later purchased the property, and everyone was welcome. This was not so at the other guest ranches in Victor Valley, which had a race policy.

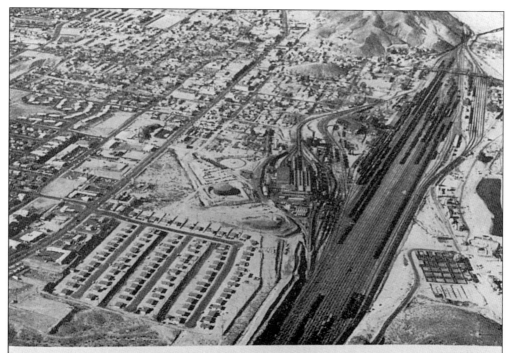

BARSTOW — THRIVING, PROSPEROUS METROPOLIS OF THE MOJAVE DESER

In this 1966 aerial photograph, Barstow is pictured as being one of the most active cities on the "Mojave." It was named after the tenth president of the Atchison, Topeka, and Santa Fe Railroad, William Barstow Strong, who was born in 1837, 34 years before the start of the Civil War. Another town in Colorado was named Strong in his honor, and those wishing to please their boss again honored him by naming this desert location using Strong's middle name. (Courtesy Mojave River Valley Museum.)

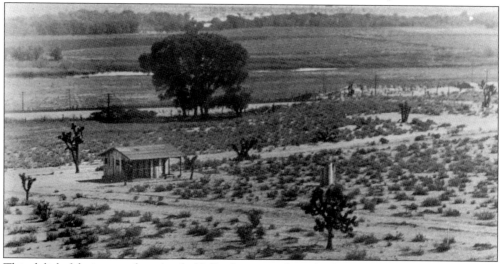

This delightful picture of an Apple Valley homesteader's shack was taken pre-World War II. The Mojave River can be seen in several places, and the roads were all graded dirt. The 1930s view appears to the author to be more inviting than many of today's modern sights, but where are the horses? (Courtesy Myra McGinnis.)

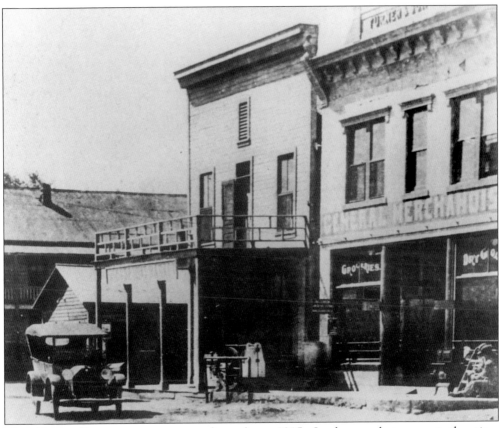

This Victorville street scene was taken about 1915. It shows what was at the time downtown Victorville's "D" Street to be quite progressive and modern. The building appearances seem to mimic those of Dodge City, KS, in looks, time, and activities. (Courtesy Jeff Goodwill Collection.)

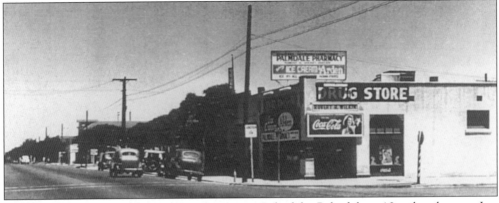

This photograph was taken in the mid-1930s in Palmdale. Palmdale is 10 miles closer to Los Angeles than its neighboring city, Lancaster. Seen here is the Palmdale Pharmacy, advertising Arden Ice Cream and Coca Cola, then selling for a nickel a bottle. This corner drug store was operated by Robert Wilkin and located on Sierra Highway. Palmdale got its name from early travelers, who saw Joshua trees and mistook them for palms. (Courtesy City of Lancaster Museum & Art Gallery.)

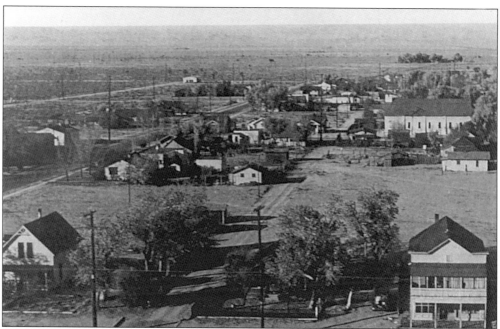

In the western reaches of the Mojave Desert, two towns, now cities, are outstanding. This 1936 Lancaster photograph looks north from the town's then water tower. The regions Catholic church is the large building in the middle right of this picture. (Courtesy City of Lancaster Museum & Art Gallery.)

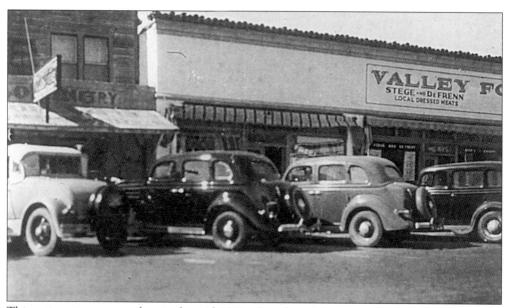

This active picture was taken in the mid-1930s. Seen here is Lancaster Boulevard at peak traffic hours. Called the downtown area, locally raised and dressed meat could be had in this and most other food markets. (Courtesy City of Lancaster Museum & Art Gallery.)

Here is more of 1936 Lancaster. The newly built Methodist church in the left center of this photograph was completed in 1929. Southern California Edison's facility is top center, where today's Lancaster City Hall stands. Three aircraft hangers can be seen at the top right belonging to the "Carter" flying field. (Courtesy City of Lancaster Museum & Art Gallery.)

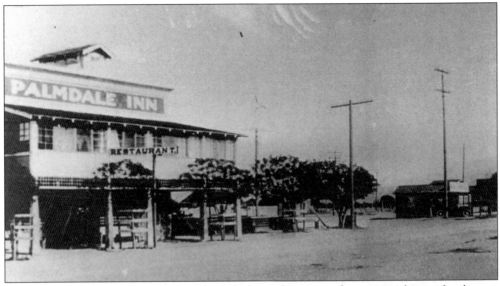

In the Roaring Twenties, the Palmdale Inn, shown here, was the center of town for dances, meetings, and visits from Hollywood's movie folk. Built on Sierra Highway, one can see the extension of business growth sprouting down the road from this famed inn. (Courtesy City of Lancaster Museum & Art Gallery.)

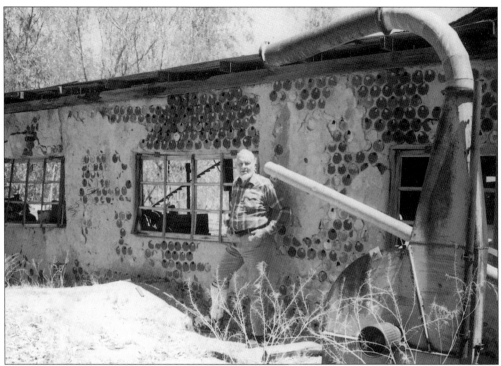

During the lean years of the Great Depression, Mojave dwellers found strange uses for things once considered trash. This Helendale scene on what is now Bob Older's Palisade Ranch shows how a prior owner, Howard Hill, put over 8,000 empty, quart-sized motor oil cans to good use. He constructed storage building walls from these given away containers, gathered from numerous oil stations. When placing the can in cement, the open pouring hole was put at the top to avoid oil left in the can dripping down on the lower wall. (Courtesy Gill Brewer, 1999.)

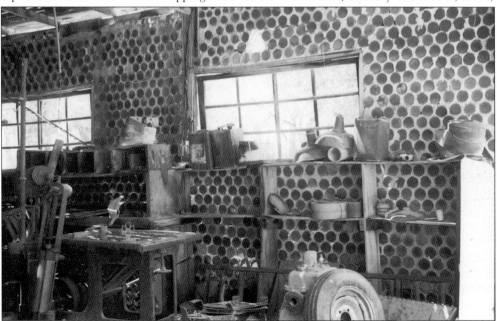

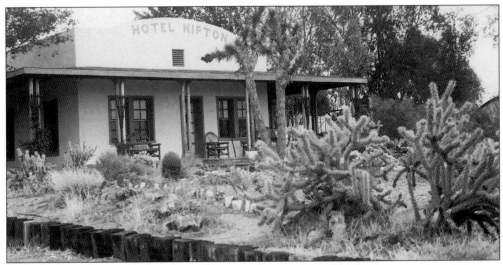

Hotel Nipton is a unique Mojave mining and cattle town lodging place. Serving travelers since 1904, it is located 65 miles from Las Vegas and overlooks Ivanpah Valley and the New York Mountains. Here, one finds serenity and samples desert life as it once was in the old west. Recognized by the AAA as a bed and breakfast hotel, the National Geographic Traveler, American Historic Inns, and others have all written about this century-old "water hole" hotel. For reservations call (760) 856-2335. (Courtesy Gerald Freeman.)

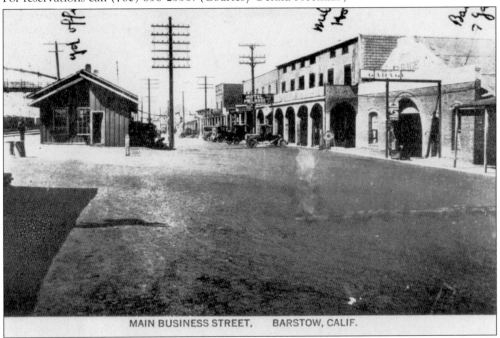

MAIN BUSINESS STREET, BARSTOW, CALIF.

Called "Old Town" now, this 1912 photograph shows Barstow growing. The Santa Fe rail yard office is shown on the left, while the Melrose Hotel, a garage, and other businesses line the main roadway. One year later, the first transcontinental road, the Santa Fe (New Mexico), Grand Canyon, and Needles Highway, came through Barstow. The first motorists emerged and their passage has never weakened, especially during the Great Depression and World War II years. (Courtesy Mojave River Valley Museum.)

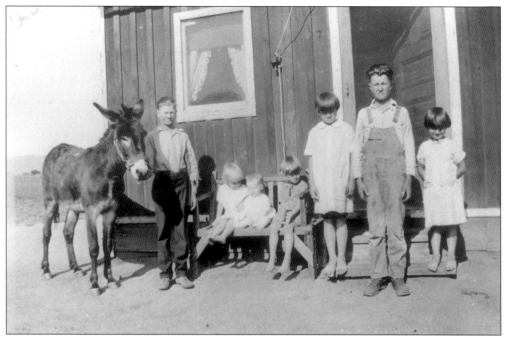

Apple Valley ranch children pose by their front door in this 1929 scene. The seven children are from the Bowen family and their burro's moniker was "Jip." Note the girls are barefooted while the boys have shoes. The fancy curtains in the window show a woman's touch out on the vast Mojave. (Courtesy Victor Valley Museum Association.)

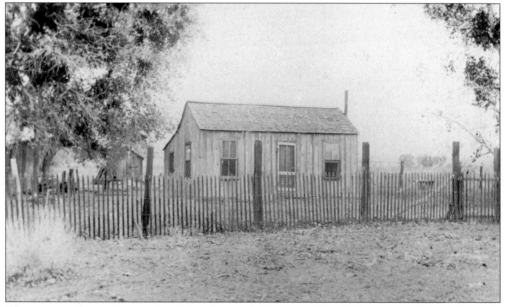

There is no white paint on the picket fence of this turn-of-the-20th-century Helendale ranch house. The bare wood fence and house appear to dream of being spruced up. Ranch members of the Robinson family, who lived here, have done some improvements. This could be a situation of being too poor to paint and too proud to white wash. There was not a lot of loose change around then. (Courtesy Mirl-Sarah Orebaugh.)

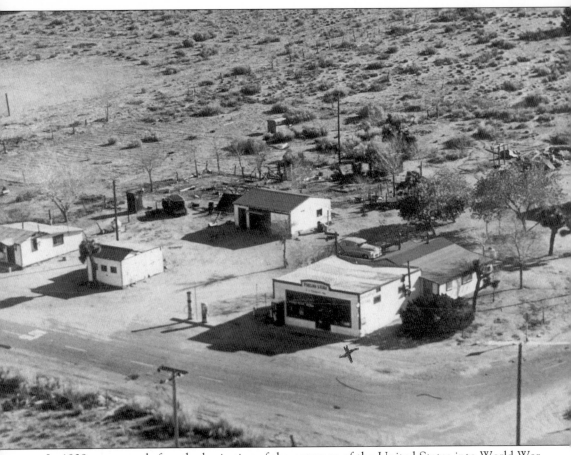

In 1939, two years before the beginning of the entrance of the United States into World War II, the tiny village of Phelan had a general store, school, gasoline station, cafe, and several commercial producing farms. At the time this photograph was taken, widely scattered residents eked out the Great Depression working on chicken ranches and picking produce. The building marked with an "x" is the 1930s Phelan Game and Supply Company, more commonly called Phelan Store. With electricity yet to arrive, this small community's store, situated on the southeast corner of Phelan and Sheep Creek Roads, was without power. In due time, the store had a 32-volt refrigerator, which kept dairy products and meat cold. Phelan was phoneless at this time, causing local residents to trek to nearby Wrightwood for their telephone needs. Along with general merchandise, the store handled groceries, gasoline, postal service, and a county library branch. From 1939 to 1942, Phelan received U.S. mail daily, including holidays. This changed in 1942, when mail came six days a week, except for eight legal holidays a year. Mrs. Ruth McDaniel was the postmaster there for 31 years. (Courtesy Ruth McDaniel, retired postmaster, Phelan.)

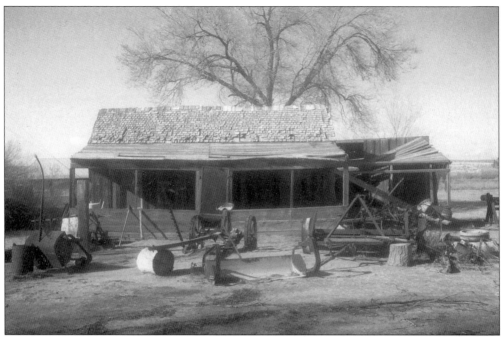

This 1920s home belonged to Ed Robinson. It was in the Helendale area, where the Robinson's ranged their cattle over many miles. Taken in 1988, the photograph shows typical damage from years of neglect, as the untiring "Mojave" reclaims itself. Ed predeceased his father, William M. Robinson, a local justice of the peace. (Courtesy Mirl-Sarah Orebaugh.)

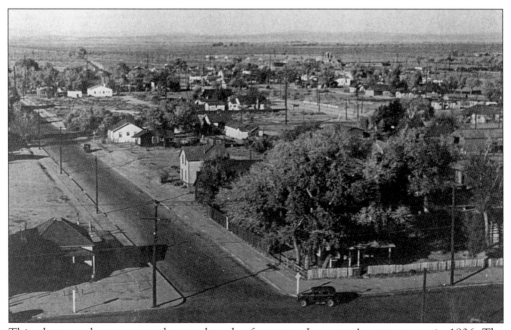

This photograph was snapped on a clear day from atop Lancaster's water tower in 1936. The scene looks north to where Rosamond Dry Lake, now the vicinity of Edwards Air Force Base, can be seen in the background. (Courtesy City of Lancaster Museum & Art Gallery.)

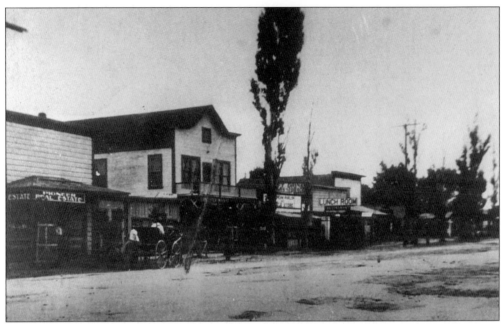

This 1914 Lancaster photograph shows commercial buildings on what was then 16th Street. The real estate office on the far left was once a midwife's clinic and later a saloon. (Courtesy City of Lancaster Museum & Art Gallery.)

This lady homesteader and tow-headed youth struggled several years, attempting to dry farm for a living. Their hopes failed and they, like many in 1917, packed up and moved to where there was ample water. Construction shown here was normal for that time. Note the modern labor-saving equipment by the front door. Parts of the 1917 cabin's water well can still be seen on this property near Zimi and Navajo Roads, Apple Valley. (Courtesy Overholt Collection.)

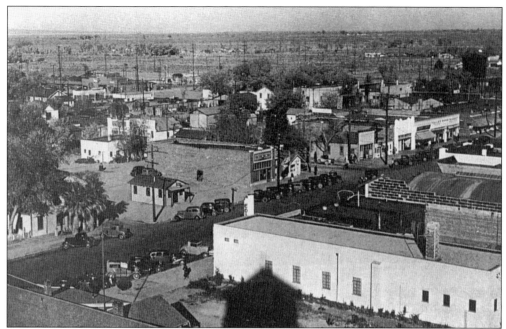

Photographer Cecil Jones, who was living in Lancaster in 1936, climbed atop the city's water tower and snapped a series of pictures from his lofty perch. This one looks northeast, and on the far left the historic Western Hotel can be seen. Built in 1888, the "Western" is the oldest downtown structure in Lancaster. It can be visited; information on this may be obtained by calling the City of Lancaster's Museum & Art Gallery.

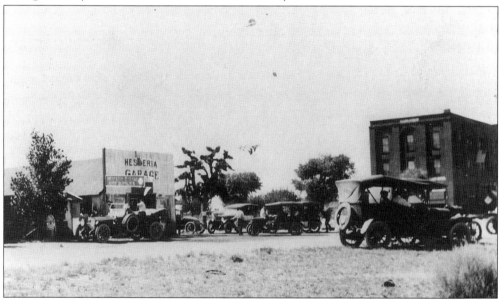

This 1915 photograph was taken on the Fourth of July next to the rail tracks in Hesperia. Both the 1880s famous three-storied hotel and the newly opened garage were on this dirt highway, then known as Santa Fe (now Hesperia) Road. Today, the street is paved, the hotel and garage are gone, and the store, not seen, remains in use. Note the steaming horseless carriage adding to the gaiety at old town Hesperia.

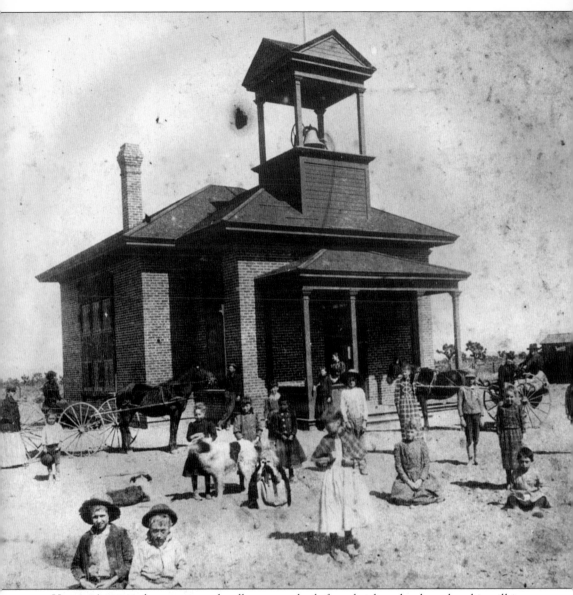

Hesperia's original, one-room schoolhouse was built from brick and redwood and is still in use. Construction began in 1883, and 23 students were enrolled on opening day in 1891. Grades one through eight were taught by a solo teacher. One of these school marms felt all kids needed schooling and would seek out children working in the farm fields and take them immediately to her school.

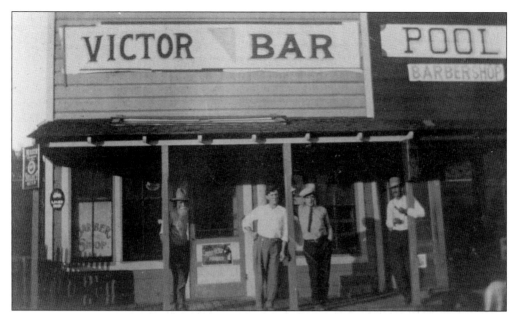

One year before America's prohibition of alcoholic beverages came to town, this Victorville saloon, Victor Bar, was helping in every way to push Victorville's reputation as being a drinking town down everyone's throats. Situated on "E" Street, the bar was two short hops from the Lark Hotel. The Lark was famous for having 25 friendly girls around and carloads of booze. Everyone was welcome, as long as they had silver or gold and were willing to part with it.

This turn-of-the-20th-century photograph shows Hesperia's White Hotel, built on the northwest corner of Juniper and Second Avenue in the 1890s. Guests were usually Easterners, who came to the Mojave Desert for treatment of tuberculosis and asthma. Diagonally across the street from this convalescent wooden rooming house stood a large Joshua tree, suitable for hanging law breakers. No records this author has found tell of the number of necktie parties that took place there; however, a few have been mentioned in aged news stories. The last hanging, according to a respected businessman and postmaster of Hesperia, was an American Indian woman who was caught with a white man in an embrace. It was believed that the man escaped, while fate dealt his companion a deadly hand.

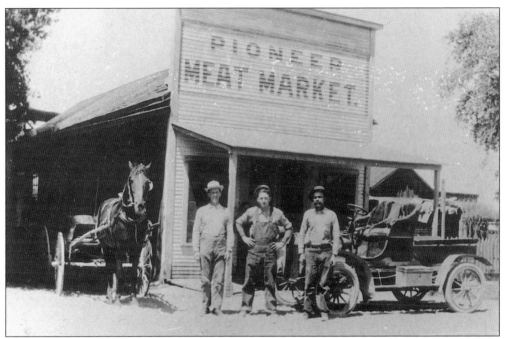

This auto versus horse buggy scene of old Daggett occurred in 1894. Frank Ryerse, an employee at this market, later bought the business. He was joined by his cousins, Homer and Ben Butler, as partners. (Courtesy Mojave River Valley Museum.)

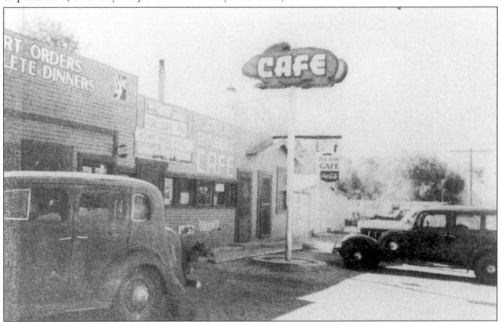

This mid-1930s photograph appears like today's main highway passing through Lucerne Valley. This was the valley's social center. In earlier times, Lucerne Valley, as now, received heavy automobile traffic between Apple Valley and Big Bear Lake. Much like Los Angeles' 1930s San Fernando Valley, housing is strewn about thinly, and most of these Lucerne Valley inhabitants feel that is just fine. (Courtesy Charles Radar.)

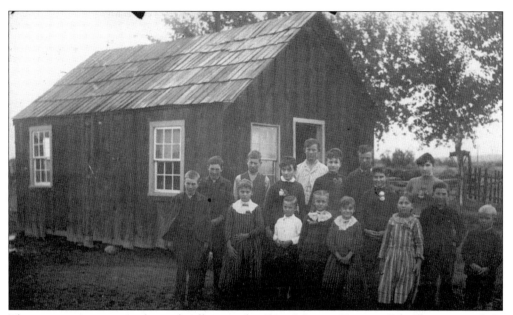

This one-room, one-teacher schoolhouse, the First Mojave District School, was on O.C. Carter's ranch in the 1870s near Bryman Road, Helendale. Another school was built when this one proved too small for an increase of students. (Courtesy Mirl-Sarah Orebaugh.)

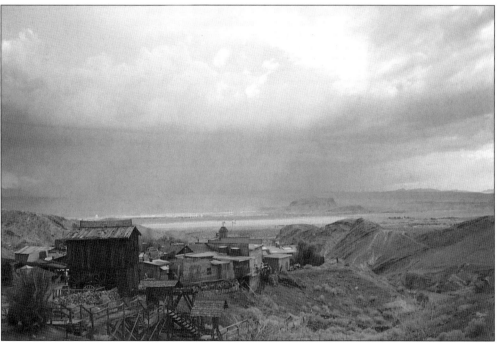

This post-World War II scene shows the mining village of Calico resting under a troubled sky. The picture was taken near the 1890s one-room schoolhouse and looks down the arroyo (right side), which is said to be where silver was first found. In 1937, three people resided in Calico, where hundreds once sought fortunes from the multi-colored earth here. (Courtesy Gill Brewer.)

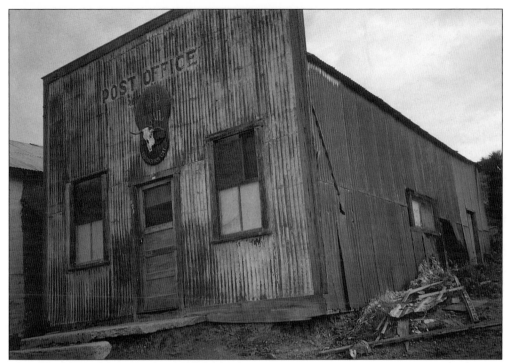

This relic of Randsburg's past tells of having once been the mining town's post office. Another aged photograph, seemingly of this post office, is quite different in looks and construction. Located in the Rand Mountains and flanked by the El Paso Range, Randsburg offered gold to hungry miners in the mid-1800s. Today, weekend amateurs scour the vicinity, hoping one more shovelful will bring them great wealth. The Yellow Aster Mine operated for 47 years in Randsburg, giving away $16 million worth of Rand Mountain gold. Once excitingly busy, Randsburg today is a drowsy and perfect place to see what a genuine mining camp looked like at the turn of the 20th century. (Courtesy Gill Brewer.)

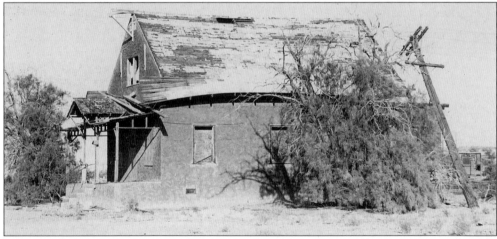

Once proudly gracing Ludlow's Route 66 passage, this neglected, venerable Mojave Desert dwelling of about seven decades past is about to give up the ghost. In all weathers, this piece of Americana has withstood the rigors of time and inattention. The once standing tall telephone pole to the house's rear also sags along with the residence in combined death throes. (Courtesy Gill Brewer.)

Here, weathering away, is the dilapidated rear entrance to Helendale's 1890s two-room teacherage. A teacherage was supplied by a gathering of citizens to house grade teachers during the school year. This 100% piece of Americana sags from neglect and disinterest. It almost stands aloof, still high above the community it once served as a comfortable home away from home for a lonely schoolmarm.

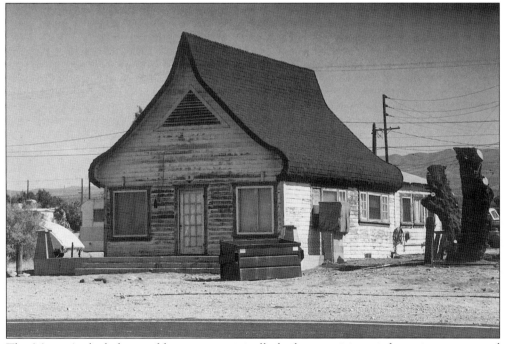

The Mojave's ski lodge roof house was originally built as a visitors information center and gasoline station in 1926. At one time, Alice Richards Salisbury, the renowned author and the Mojave Deserts "poet laureate," lived here. It continues to be a private residence.

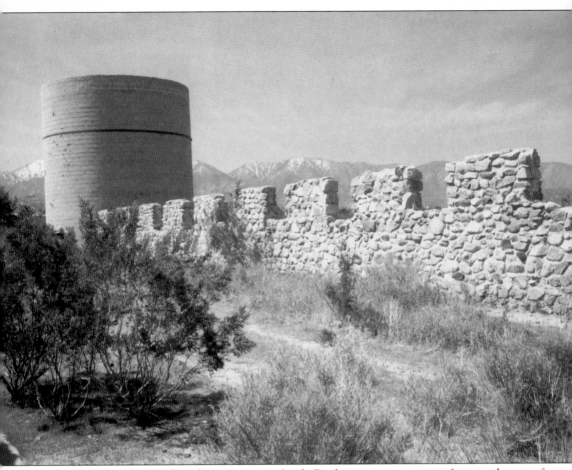

Llano, an Antelope Valley ghost town near Little Rock, rests in peace now from its dreams of becoming utopia. Originally called the Llano del Rio Cooperative Colony, its hopeful people have gone, and silence now surrounds the area. It is claimed that actor John Wayne, living in Lancaster and Palmdale as a boy, attended grade school in this vicinity, along with children from the colony. Founded on May 1, 1914 (May Day), Job Harriman, a Los Angeles lawyer and fervent socialist, was the power behind this cooperative undertaking. He bought a large land tract with water rights for nearly nothing and set out to cure his followers woes. All here believed they could soon change the Joshua and Creosote dotted land into an agricultural and commercial oasis. People came here in Llano's heyday from every walk of life, some with money, some without. Finally, in 1918, everyone there became dissatisfied and walked away from the failing daydream. Today, chimneys, pillars, and other ruins are still evident. This 1996 photograph shows the empty silo and dairy barn walls, where at one time, 100 milch cows supplied the dairy needs. As to Llano's highest population figures, it seems between 900 and 1,000 socialist comrades tried their luck here. It never came. (Courtesy William Couey.)

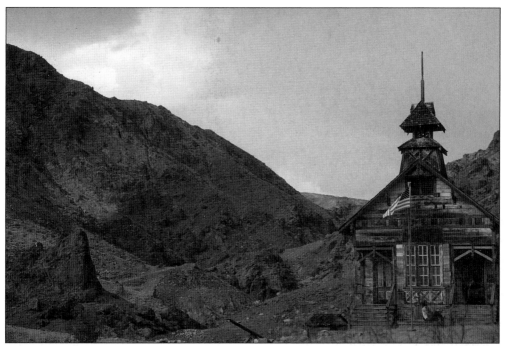

The Calico Mountains and Calico's 1890s one-room schoolhouse stand proudly for all to see. Nothing much existed beyond the school except cave-like miners dwellings. From this photograph can be seen the various colored earth that gave the village, which is now a public park, its name. Called Ghost Town Calico, it is located halfway between Lake Dolores and Barstow on Interstate 15. (Courtesy Gill Brewer.)

In 1930, Lucerne Valley boasted having this post office building on the Box "S" Ranch in this widely homesteaded area. Famed for its pure "Mojave" dry air, World War I veterans who suffered being gassed in France found breathing here easy. One section of the valley is called "Little Inglewood." This stems from many homesteaders, originally from Inglewood, CA, moving there in the 1920s and 1930s. (Courtesy Charles Rader.)

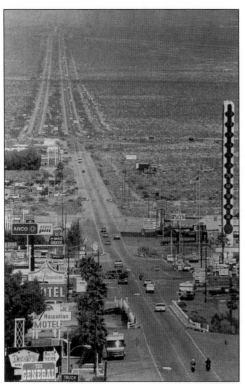

Baker, CA, is referred to by many as the heart of the Mojave Desert country. The world's tallest thermometer, raising 134 feet above Baker, is visible here. It was a promotional idea to commemorate the high summer heat felt in Baker and nearby Death Valley. Five hundred people now call this oasis "home." Home to them is the beauty of the Mojave, the peace and quiet of the surrounding desert, and living in awe at the vast empty spaces of the barren, wind-swept lands.

This bar-free jailhouse kept outlaws under control in the late 1880s. Daggett's unruly citizens were detained in this approximately 10-by-15-foot cage. Constructed from railroad ties, the summer heat inside became an oven, while winter coldness seeped into everything. Imagine four or five men locked up inside this hoosegow. No one ever wanted to return. Hesperia also had a railroad tie (6-by-6-foot redwood) jail with no windows in the 1890s, located across the road from the Hesperia Hotel. (Courtesy Myra McGinnis-Swisher Collection.)

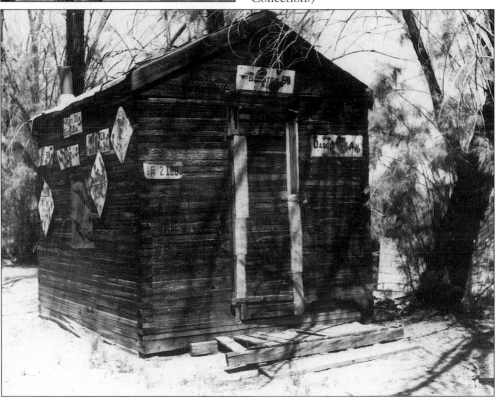

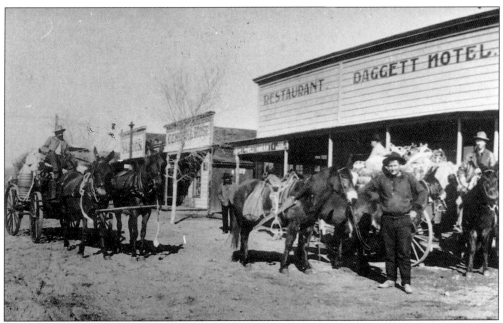

The year 1905 was a grand one for Daggett. It was doing well commercially, as seen in this photograph showing the People's General Store, Daggett Hotel, and a restaurant. The famous Death Valley Scotty appears here in the right side foreground. He made Daggett his headquarters when away from his borrowed castle and non-existing, valuable gold mine. (Courtesy Mojave River Valley Museum.)

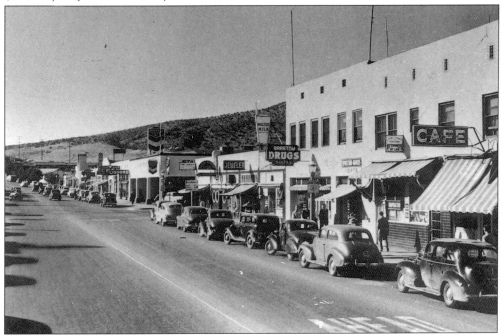

Here's how 1947 Barstow looked soon after World War II. This photograph looks west from Second Street on Main. There was a fortune here in antique automobiles just sitting idly, and they were likely on sale cheap—back then. (Courtesy Mojave River Valley Museum.)

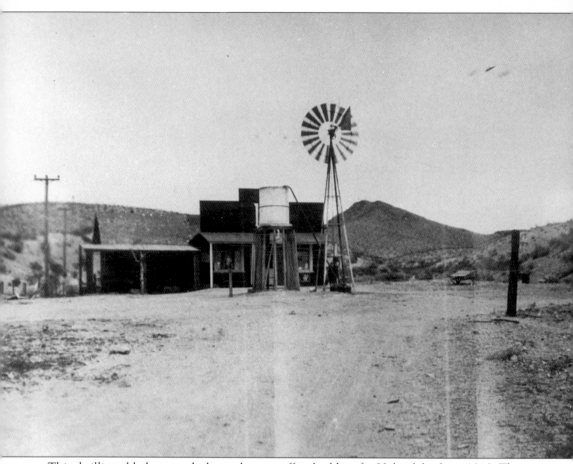

This thrilling old photograph shows the post office building for Helendale about 1918. Thomas J. Gordon was sworn in here as postmaster on October 26, 1916. He was followed by Lula B. Chapman on May 2, 1918. The hill in the background appears to be where a World War II–era air raid lookout station was placed. (Courtesy Mirl-Sarah Orebaugh.)

Two
Thirty Bucks a Day,
Once a Month

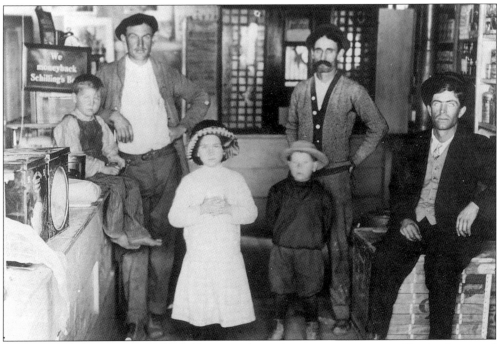

A common practice in the early 1900s was to have the community's post office in the rear of general stores. At the time this photograph was taken, Oro Grande was named Halleck and the postmaster of the 1880 post office was L.P. Jones. This photograph was found in a store in Oro Grande years later and had nothing on it about the people or exact date. (Courtesy Antique Station, Oro Grande.)

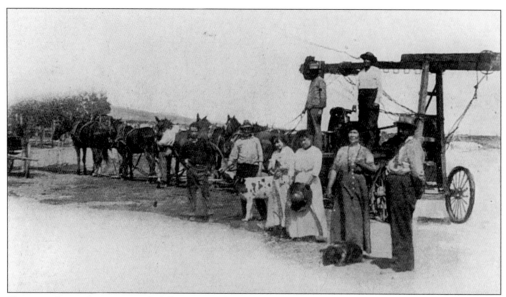

Yermo, where the present California Border Inspection Station is, once boasted to having this and another water well digging rig available for finding water on the Mojave. The Thomas Williams family is seen here in the "Garden Spot of the Desert" scene, named as such in the 1914 edition of the women-operated and written magazine *Kingdom of the Sun*. (Courtesy *Kingdom of the Sun*.)

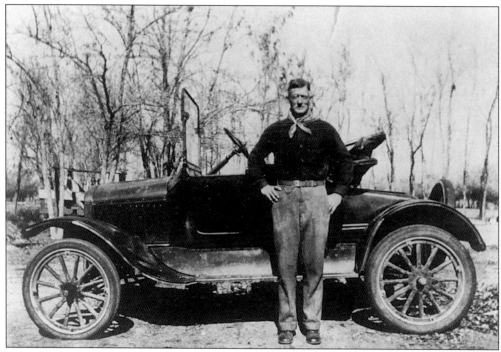

The spitting image of actor John Wayne, the late Tex Thomas of Hodge stands next to his beloved and often cursed at Ford. Thomas's coupe sold in those days for $525, a lot of money when this 1926 photograph was taken. When buying these Fords new, fix-it tools for repair jobs came with the car as aid for frequent breakdown problems. (Courtesy Henry Jay.)

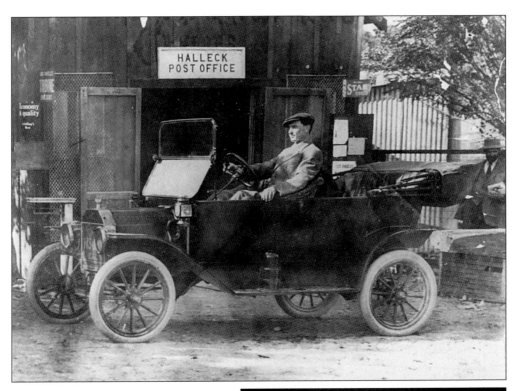

Called a Jitney in 1912, this touring car taxi provided service for Halleck (Oro Grande) citizens. The late Penny Morrow, a true Mojave native son, is shown here in his 1912–13 Ford T. In 1880, name changing started, and with time, Oro Grande won over Halleck. At one time, it was larger and more commercial than Victorville, then called Victor. (Courtesy Antique Station, Oro Grande.)

This not-so-long-ago number board was used for years as a means of keeping tract of the "working girls" at Red Mountain's Owl Hotel. Located 25 miles north of Kramer Junction in the west Mojave, girls of the line sold their charms there from 1918 to 1954—36 wild years of wine, women, and yodeling. Each girl had her own number on the board, which showed if she was busy or not. Eight "fille de joies" staffed this bed-and-no-breakfast tavern. Today, the "Owl" is open for antique loving souls and for some reminiscing. (Courtesy Ed Lemoine Collection.)

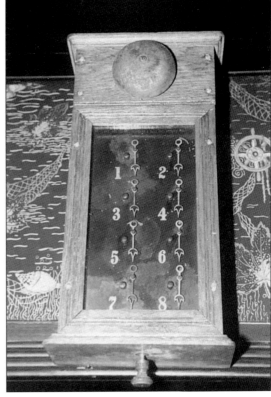

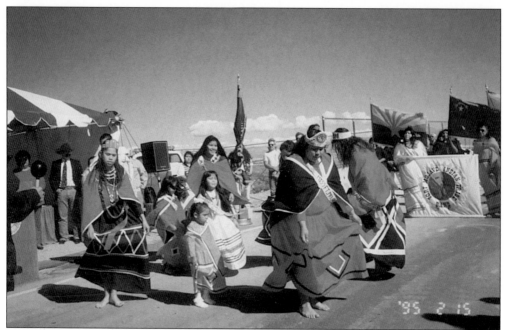

Colorful Mojave Indians are celebrating the opening of a new auto bridge spanning the Colorado River. This cross over connects Arizona with Nevada's Mojave Tribal Avi Hotel and Casino. Located near Laughlin, NV, these natives, in large part, live on reservation land where their ancestors farmed and fished the banks of the Colorado. (Courtesy Maggie McShan-Needles Museum.)

Rebuilt in 1894 after a fire, this blacksmith building helped build 20-mule wagons for carrying borax. Some of these weathered pieces can be seen in the now fenced yard. Known as the Alf's shop, Daggett, all of the original tools and equipment used there in the 1890s remain as they were when Alf closed his business and walked away. (Courtesy Gill Brewer.)

Here stands the building all Victor Valley old-timers affectionately called "the old sheriff's office." For years, it stood on Victorville land owned by lawman Ed Dolch. It was later moved and used by real estate people in Apple Valley as a sales office. Arriving from Adelanto in 1908, parts of this building were said to have come from Aaron Lane's 1850s ranch, south of Turner Ranch Road in Victorville. San Bernardino County got around to using it for city hall purposes as well as sheriff, cattle inspection, state relief, Red Cross, military police, notary public, highway patrol, dynamite permit, and marriage license offices. Fading with its past, in 1978 Apple Valley crews began its demolition. (Courtesy Gill Brewer.)

Mrs. Joshua A. Thomas is shown here holding the family's branding iron "6T'S." Mr. Thomas was noted for his truck garden, raising cattle and horses, and being a helpful leader in many public projects. Ives, Mrs. Thomas, was a founder of the Bell Mountain 4H Club in the 1940s. The brand referred to the six Thomases in their family. Bell Mountain is north of Apple Valley. (Courtesy Marian Tate.)

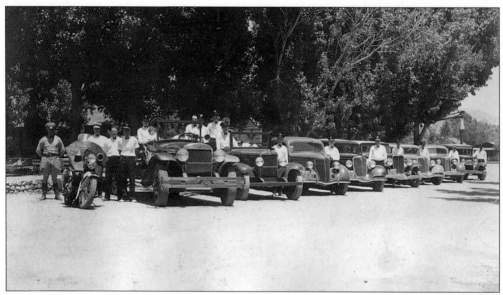

Victorville's finest are seen here in a 1936 picture showing the newer vintage fire automobiles up front with the oldest cars in the back. One wonders if these men shined their shoes brightly for this public relations effort. If so, it appears that their time doing such was wasted. (Courtesy Thelma Antony-Swisher Collection.)

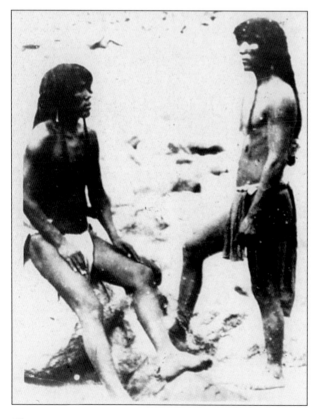

Few pictures of Mojave Indians are available; however, this one shows how these tall (some 7 feet in height) men appeared to outsiders crossing the Mojave Desert in the 1840s. This desert tribe was one of the last to bow to the will of white men. They enjoyed political, economical, and social well-being as well as stature. One early report tells that these Mojave natives' physical condition, stamina, and mental abilities far outclassed the majority of the non-desert native tribes of North America.

Positively nothing is known by the author about this exciting Mojave Desert palace-shack at Atolia. Likely built during the World War I era or later, it housed a mining family. Tungsten, a metallic element that resists high temperatures and corrosion, had been mined on and off at Atolia, near Randsburg, for years. It can be brought from China cheaper, while local findings are more expensive. (Courtesy Gill Brewer.)

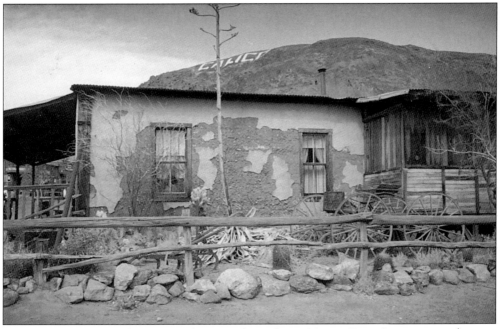

This 1890s cabin-store shows normal wear and tear due to Mojave Desert's continuous drain on man-made items and materials. Nestled along Calico's main street, one can see that time is not waiting for anything. However, dry desert weather preserves things far better than most places, and that includes human beings. When the author visited Calico in 1937, only three people lived there. (Courtesy Gill Brewer.)

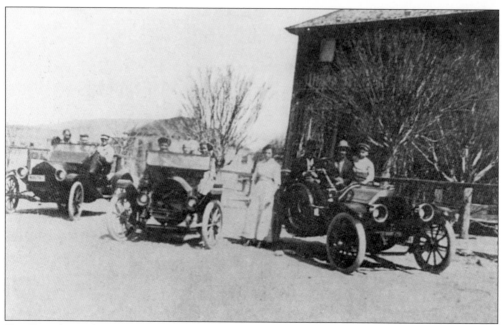

Oro Grande, in the 1910s, was most proud of its two-story prosperous hotel. It was managed by G.T. Sargent and was one of the popular chain hotels the motoring public liked to visit. Known as "Havens of Rest," this hotel was in competition with Hesperia's well-known, three-story hotel made from Mojave River bricks. (Courtesy *Kingdom of the Sun*.)

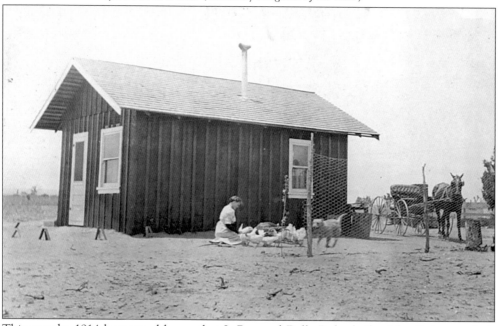

This was the 1914 homestead house that LeRoy and Della Rolar built. After living on their chosen land for a set time and making improvements, the property would pass from the United States, free and clear, to the homesteader. The Rolars home sat where today's Interstate 15 rolls along on Hesperia's extreme west side. Della is seen feeding her leghorn chickens in the vicinity of today's Outpost Truck Stop. (Courtesy Mabel Widney.)

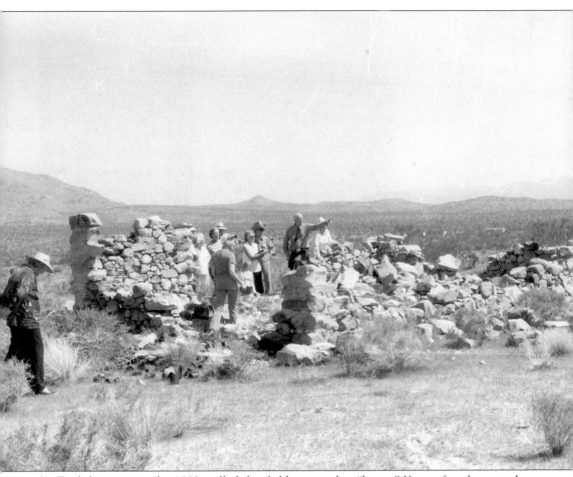

An English citizen in the 1880s called this field stone cabin "home." Years of neglect, apathy, and weather have taken their toll, and the Mojave Desert is reclaiming its land. Located in sparsely populated Fairview Valley (east of Apple Valley), the land and cabin were later purchased by Apple Valley founder Newt Bass in 1945. Prior to then, the Englishman had the only good water well in the vicinity.

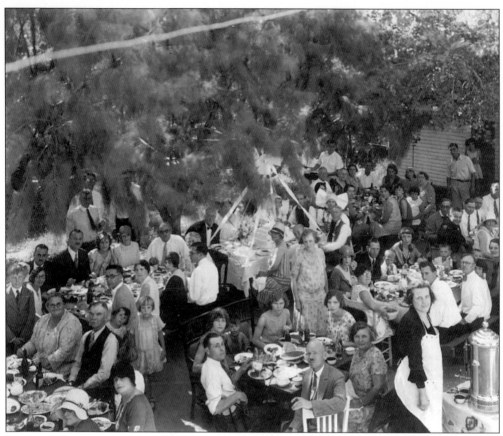

Lenwood, down the road from Barstow, hosted this happy wedding reception. Dated September 1929, the wedding was a traditional Czechoslovakian affair. Forty women wore large ancestral copied bows in their hair, while a number of men with "Old World" ties dressed in knee trousers, embroidered vests, and black boots. The bride was Mary Kucher of Los Angeles, who married Adolph Gallas from Pilsen, Bohemia. This traditional marriage was held outdoors, and all present were required to stand throughout the entire ceremony. (Courtesy Jack Gaffney.)

What bride could ask for more than to have a true flat iron she could call her very own?

These four bathing beauties were happy modeling their 1926 swimsuits. Today, most swimsuits don't swim. Photographs of this subject are rare for the 1920s, even if those years were called, "the Roaring Twenties." High school books did not condone such a show of femininity in most cases but Victor Valley Union High did in their annual Joshua Tree publication.

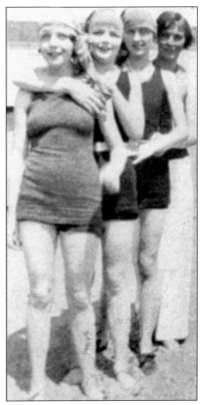

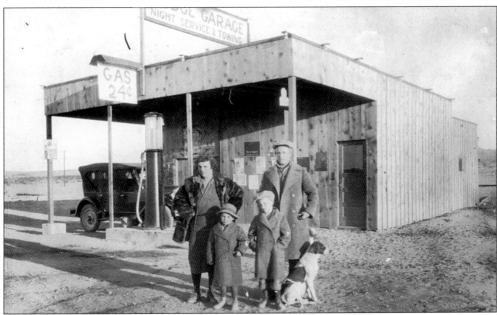

Offering night towing and full garage service to the 1925 motoring public, the Hodge Garage was owned and operated by the Jay family and Queenie, their helpful dog. Hodge, CA, is on old Route 66, between Helendale and Lenwood. It appears to be winter on the "Mojave," for the Jays are wearing heavy clothing. It can get quite cold in the desert. (Courtesy Henry Jay.)

As a man of 28 years, Wyatt Earp was a deputy sheriff in Dodge City, KS. History refers to Wyatt as being an American frontier marshal. Shoot-outs and gun play fill books about this man, who lived five times more of his life mining on the Mojave Desert than he did wearing a lawman's badge. For years, Earp worked mines scattered 6 miles north from a tiny spot on today's California State Highway 62, named in his honor. He passed away on January 13, 1929.

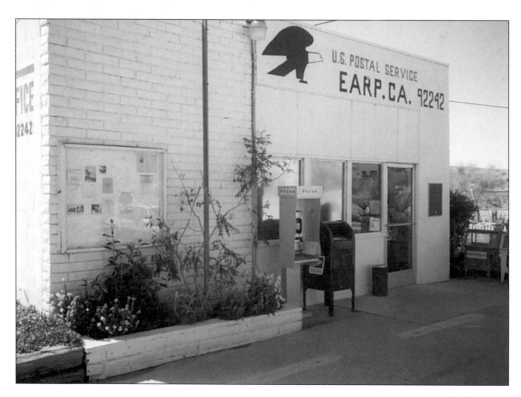

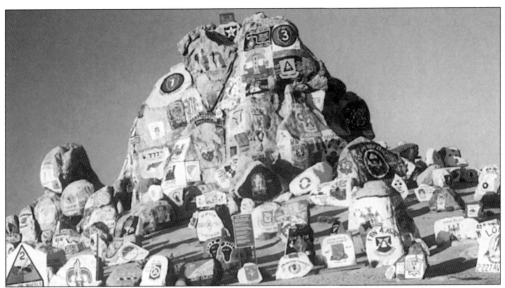

If ordinary citizens put their graffiti on Mojave Desert rock piles, chances are they would be arrested, jailed, and fined heavily. However, the U.S. Army shows its feelings loud and clear in this desert mutation scene as visitors approach Fort Irwin, 35 miles northeast of Barstow. In 1998, the army lobbied hard to take more Mojave lands for themselves and leave much less for everyday people to enjoy. Likely, the army believes all this unit scribbling is good for army moral and what they do to "their" desert is not anyone's business. Obviously, the army feels its way is best. There are many who agree that this painted mess on desert lands is a hideous violation of the Mojave Desert's rights. It is totally unnecessary to deface any part of nature's treasures to announce "Kilroy was here" by any group or person.

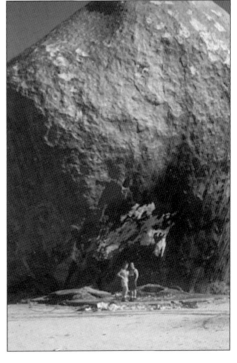

Two visitors to the Mojave's "Giant Rock" are seen in front of where, during the World War II era, a nazi spy died. Frank Critzer was the person who squatted without homestead rights at this isolated desert site. Critzer was being investigated by various authorities who became suspicious about his hand-made aircraft landing strip. Also, numerous short wave radio signals were traced to the rock. Without help, he dug under this massive granite boulder, weighing an estimated 26,000 tons. Thirty feet above his cave quarters, on top of the rock, were other suspicious items like 4,800 feet of copper wire mounted on 8-foot metal poles cemented into his rock home. One room measured 24 by 20 feet and joined another room 10 by 10 feet, which held his radio equipment and generator. On July 24, 1942, three deputy sheriffs attempted to arrest Critzer, who within minutes set off dynamite hidden about the rock, killing him immediately and wounding the deputies seriously. The explosion raised the boulder a full 17 inches. (Courtesy Gill Brewer.)

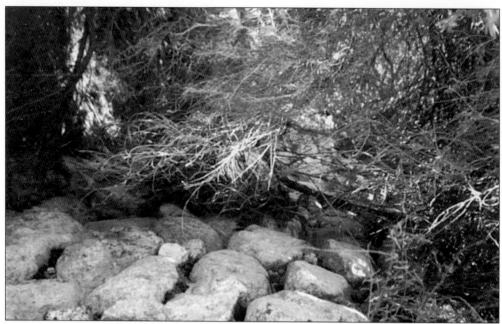

This stone-quarried wall is the largest portion remaining of an 1884 Soledad Canyon wood pulp mill. English money financed this improbable "pie in the sky" scheme where wasteland cactus, Mojave Joshua trees, would be cut into 2-foot logs and made into useable newspaper sheets. A London, England, publishing house purchased 5,200 acres of aged Joshua trees, which were harvested by a small army of Chinese "coolies." The logs were crushed into pulp at the mill. Mildew often occurred while shipping this product, and the paper proved inferior and unsuitable for newsprint. This water-driven mill was damaged severely after a passing flood tore up the countryside. Several attempts to turn Joshua trees into useable paper have taken place since the 1886 wash-out, yet nothing has resulted in success, and now the law is protecting these wonderful yet somewhat grotesque Yucca Palms, the Joshuas.

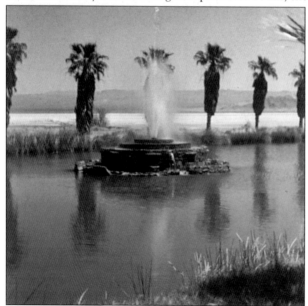

A rare sight indeed are the Zzyzx Springs gushing a water fountain and the desert palms. This man-made pond welcomes all who venture to the Mojave's Soda Springs, 10 miles southwest of Baker. Zzyzx ("zigh zix"), the true name of Soda Springs, came from a 1854 railroad survey. The now more used name, Zzyzx, came from Curtis Howe Springer, who invented the moniker in 1944. The area is now used for higher education purposes.

The United States Civil War began in 1861. Two decades before that, men formed a secret organization to dissolve the Union and establish a Southern empire. They were members of the Knights of the Golden Circle. California acquired a large army of people, showing southern leanings, who shared their wealth with Richmond, VA, the Confederate's seat of power. Holcomb Valley had a lot of gold and many patriotic Southerners. Some of these true blue Confederates formed a Golden Knights circle at Cushenbury Springs, south of Lucerne Valley. There they would gather in membership to help states' rights causes, both in sending money and horses as well as recruiting men for the South's armies. As new members joined, they would plant a tree for themselves in an existing circle of trees. In time, Cushenbury Springs had an outstanding grove of circled trees, which in part can still be seen.

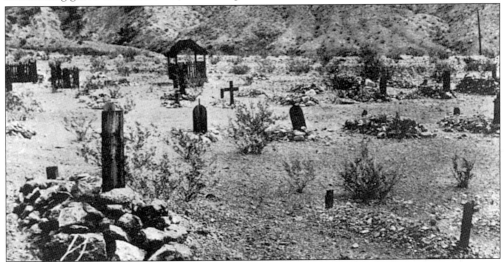

Folks stay dead a long time if buried at Calico! This 1880s cemetery had plenty of mining people laid to rest here through the 1890s. Burials ceased about 1905, when the silver price gave out and the mines closed. A quiet place, Calico was not known as a gunfighters' spot nor was there a problem with the shootings other mining camps experienced. One body still there, belonging to a fellow named Zackera Peas, had the following epitaph on his now missing headstone: "Here lies Zackera Peas, in the shade under the trees. Peas isn't here, only his pod. Peas shelled out and went home to God." Since the mid-1930s, Boot Hill has suffered a great loss of tombs and headstones, and large numbers of grave sites have been vandalized and destroyed.

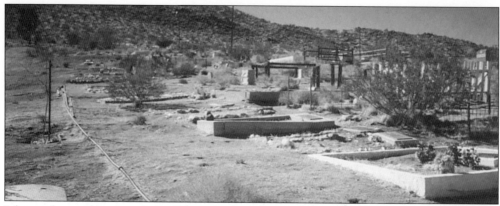

Johannesburg, CA, shared the "glory days" with Randsburg (where gold was mined), Red Mountain (where silver was mined), and Atolia (where tungsten was mined). "Jo Burg" is a Mojave high desert village sandwiched between Red Mountain and Randsburg. "Jo," another moniker, enjoyed as fine a cemetery as any wide open space mining region had in the early 1900s. Carrie Ovall, poetess, long ago authored the following poem, telling how being buried was tied to desert folks feelings. Her lifestyle poem is found posted at the entrance to this cemetery, which is still in use:

> Lay me down on the hillside at JoBurg,
> Where the desert winds sweep by,
> Where in row upon row of little brown tents,*
> My former companions lie . . .
> With only sand as a blanket, Instead of a flower strewn sod,
> My body shall rest from it's labors,
> When my spirit has gone out to God.
> I tramped those hills in the sunshine,
> On the desert I'd live and die,
> Let me rest on the hillside at JoBurg,
> Where the desert winds sweep by . . .
>
> *mound of dirt piled above grave and ground level.

The Mojave has yet to fully reclaim these 1851 wagon ruts and trail. Located on the Bob Willians Victorville Ranch, clear evidence still lingers there where 150 years ago, a mass departure of Mormons left Utah for San Bernardino and passed along here. Few artifacts exist on the trail today; however in the past, dolls, toys, and equipment still dotted the way where, seven years later, some would pass again, returning to Utah. This is a 1991 photograph, looking south toward George Air Base Road.

52

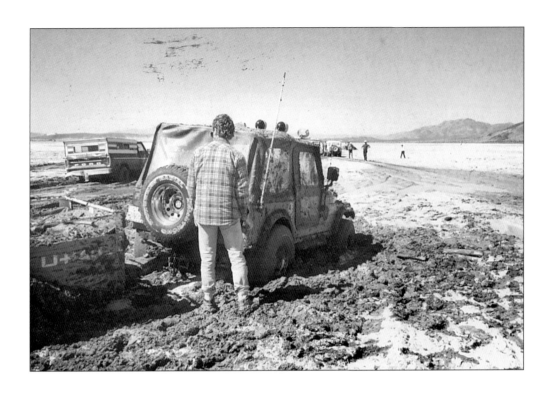

This wonderful excursion took place in the early 1990s at Soda Lake, near Zzyzx. The author was among these happy vacationers giving every indication that the party was over. Soda Lake is where the north-flowing Mojave River reaches before it is no longer seen. Sometimes it is referred to as being the sink of the Mojave River. Soda Lake is usually dry, but at times it contains pools of salty water.

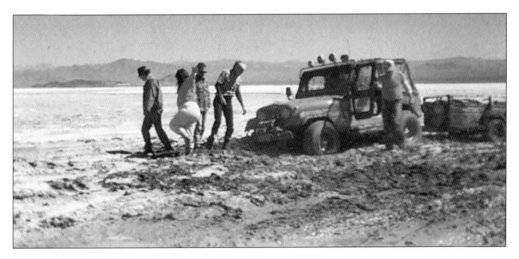

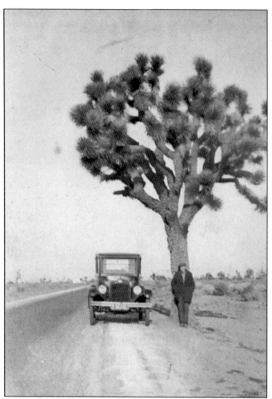

This giant Joshua tree grew for more than a century before LeRoy Rolar parked his 1930s car beneath it. At this time, U.S. Route 66 was called California State 31-C. Mr. and Mrs. Rolar owned and staffed a gasoline service station with lunch counter snacks on homesteaded property. When Route 66 was enlarged, this venerable Joshua tree was cut down and cast aside. (Courtesy Mabel Widney.)

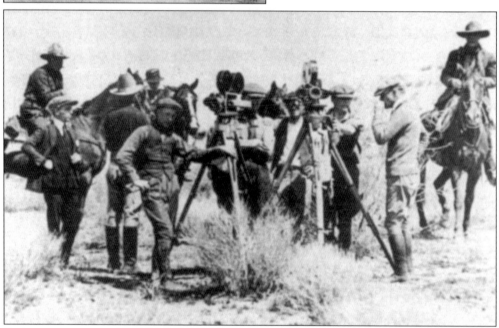

Business managers, publicity directors, and cameramen are seen here preparing for a movie shot filming wagon tracks in the sandy soil around Victorville. The year was 1919, and cowboy master actor William S. Hart can be seen on his horse at the far right in the picture. (Courtesy Seaver Center for Western History Museum of Los Angeles County.)

During the 1930s through the 1950s, Victor Valley was awash with "dude" guest ranches and special lodging places for Hollywood movie people. Stars and others wishing for a taste of the Old West visited these spots on a steady basis. Silent film comic Ben (cross-eyed) Turpin reportedly died in 1940 on one such Apple Valley home-ranch. His remains were quickly removed to Los Angeles, where his death was then recorded. Pictured here, from left to right, are movie star Pat O'Brien (1899–1983), an unknown rider, and Henry Fonda (1905–1982). The location of the threesome was the Yucca Loma Ranch, Apple Valley.

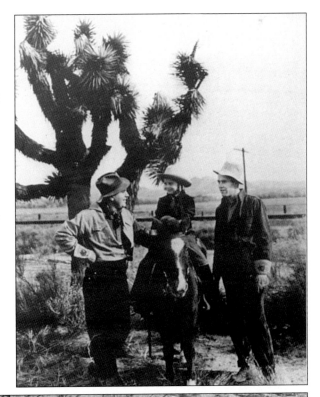

In honorable use as Helendale's "old" one-room schoolhouse, this red building was in active service in the 1920s. It was later moved several miles from its original location to Helendale's West Ranch. When relocated, it was turned into a private resident, as seen here. All that is missing in this scene are chickens scratching about. (Courtesy Mirl-Sarah Orebaugh.)

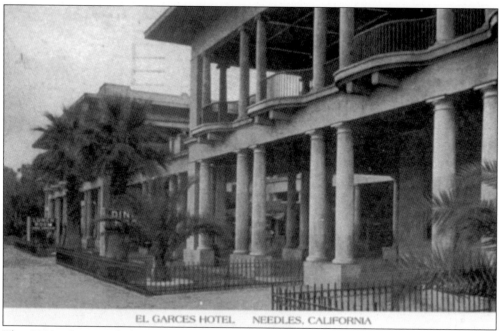

EL GARCES HOTEL NEEDLES, CALIFORNIA

This 1930s photograph shows the beautiful Santa Fe Railroad Station in Needles, CA, during one of its greatest times. Known as the Santa Fe Station and Fred Harvey Curio Home, it was one of several border crossings to welcome Easterners into California, either by rail or vehicles. (Courtesy Maggie McShan-Needles Museum.)

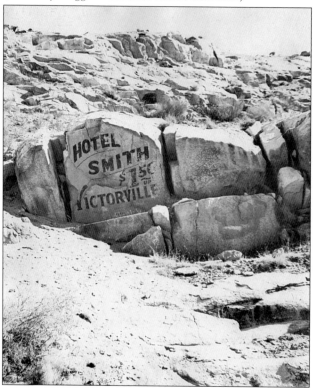

Now extinct, Hotel Smith was a popular Victorville inn, located at Sixth and "D" Streets. The management advertised widely as having lodging for $1.50 per night. One of Smith's signs, prepared with now outlawed lead paint, is still in good condition. Painted in 1930, this graffiti-type advertising has remained legible for over six decades. Placed at eye level along the old Apple Valley-Victorville road, through the Upper Narrows, this public notice is still trumpeting up trade for Victorville's Smith House, which is no longer there.

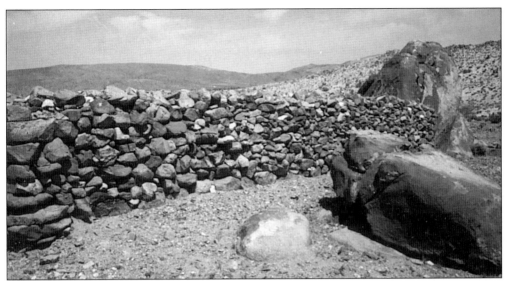

This little-known Mojave Desert landmark is about halfway between Daggett and Lucerne Valley, off Road 247. Hundreds of feet of heavy field stones are piled 4 feet high, as well as wide, making fort-like enclosures. George and Mildred Willis entered the Mojave in 1905 to try cattle raising. Digging a water well on their land, they found water at 20 feet. An abundance of rocks lay in all directions, suitable for building material. In 1915, the Willises moved 50 head of cattle on their desolate ranch land that needed corrals. For the next ten years, they constructed rock fences 660 feet long, excellent for holding pens. Mildred is said to have done most of the hard work with George, a former mining man whose health was questionable, helping as he could. They remained at the well site, Willis Wells, until 1926. George died shortly after, and Mildred never again returned to this landmark ranch.

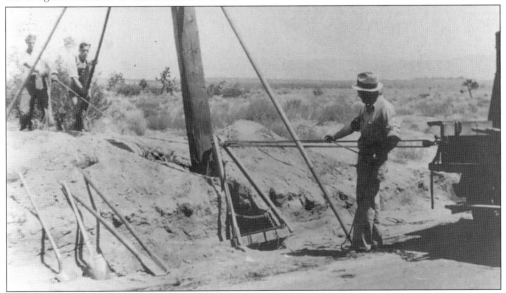

Electrician Lewis Sidney Powell came to the Mojave Desert in 1927. His first employment was in Victorville caring for the only power plant for miles around. Lewis and his wife, Evelyn, ran an electric store on Seventh Street in Victorville for years. Powell is shown here placing new poles for the arrival of electricity to Apple Valley. (Courtesy Evelyn Powell.)

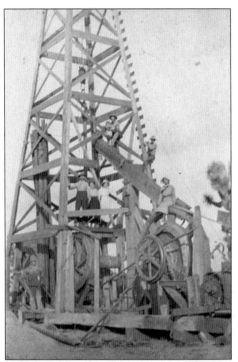

In the 1930s, black gold fever was flooding through the blood of many Mojave Desert landowners. This Hesperia oil derrick was built in 1932 on F.H. Hunt's property, near today's Outpost Truck Station. Local homesteaders invested $1,000 in hard times money, expecting to make it big with this bone dry, non-gusher. Four oil wells were drilled throughout the Mojave before 1912, and by 1928, a government paper said that the wells either showed no trace of oil or it was not a large enough pool to warrant pumping. It appears homesteaders in Hesperia did not agree with those reports. (Courtesy Mabel Widney.)

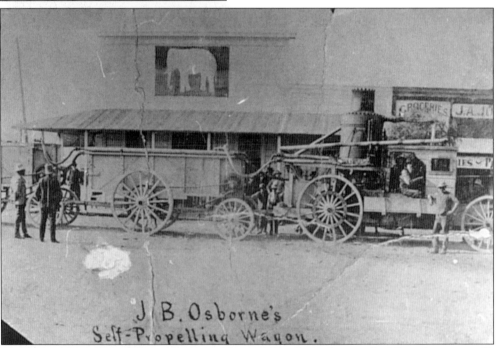

J. B. Osborne's
Self-Propelling Wagon.

So who or what attempted to replace the Mojave Desert's working mules? Seen here is a self-propelling wagon, called such in 1914. Someone in the Alf family of Daggett secured this photograph of J.B. Osborne's steam tractor. These heavy rigs proved a disappointment to desert haulers, who returned shortly to using four-hoofed critters. (Courtesy Mojave River Valley Museum.)

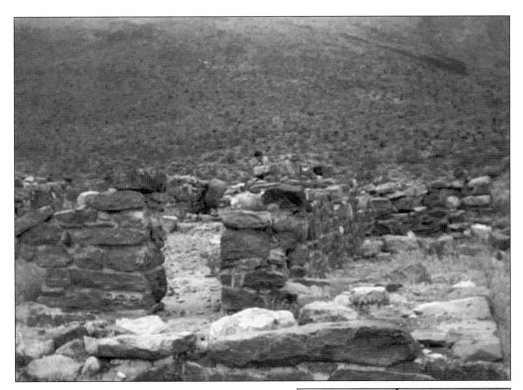

Here are the remains of Fort Piute, strategically located on the Mojave Trail and manned by U.S. soldiers from 1866 to 1867. The now crumbling stone walls greeted travelers with some degree of protection from native bows and arrows. Fort Piute also aided California-bound Easterners with assistance and extra protection as they rolled west. Petroglyphs chipped into rocks are plentiful here, telling that this location was once used for native ceremonies before Fort Piute was built and, likely, after the soldiers left.

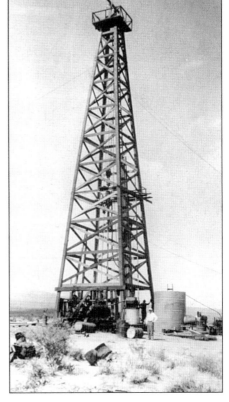

This Lucerne Valley oil derrick was being worked in the mid-1930s. Drilled south of Rabbit Dry Lake, a cutting bit was lost at a depth of 1,465 feet. No commercial oil products were found throughout the Mojave Desert anywhere. Major efforts were made to bring in a "gusher"; however, all who attempted to find the black gold were royally disappointed.

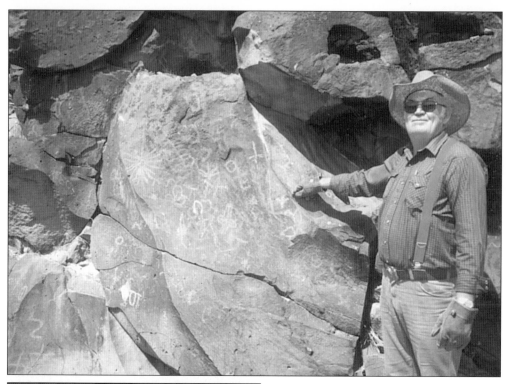

The late John Tye, amateur historian and onetime range cowboy, is seen here pointing to an unusual petroglyph near Rodman Mountain. These many and varied pieces of native rock art are hundreds of years old. They are said to be scenes from a drug-related sleep that all males were required to endure when passing into manhood.

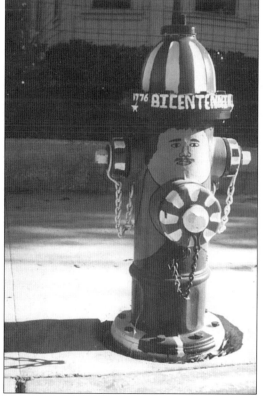

"Okies from Muskogee," the song, has not any more patriotism than Mojave non-okies enjoy. High, undying love for country, community, and county have, since the 1800s, been displayed in everyday happenings as "Mojave people" go on with their lives. During the 1776–1976 Bicentennial, Victorville painted their fire plugs using a patriotic motif. Somewhere along Sixth Street, the fire plug, as shown, brought humor and joy to those seeing it. (Courtesy Gill Brewer.)

Three

BEHOLD HOW SWIFTLY THE SANDS FLOW

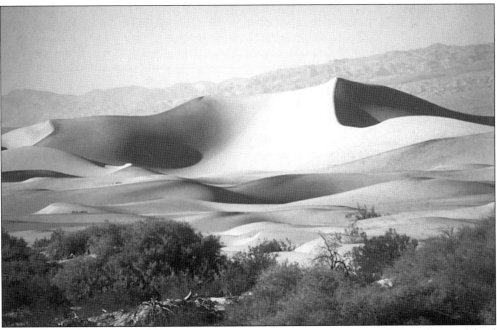

Adjacent to the Mojave Desert, many feel "Tomesha" should be included in that arid land mass. Actually, native Shoshone tribal members, living in what today is Death Valley, called their homelands "Tomesha," meaning "Ground Afire." Death Valley covers 550 square miles and at one point drops to 280 feet below sea level, the lowest point in the Western Hemisphere. Now a national park, "Ground Afire" has suffered through summer heat spells reaching 134 degrees officially and likely hotter ground temperatures nearing 140 degrees and more. Within this valley are numerous regions of various unusual sites. One piece of Death Valley is its sand dunes close to Stove Pipe Wells. Many Hollywood filmings have been made here, where desert breezes rearrange continuously, spreading massive sand piles into different shapes. (Courtesy Gill Brewer.)

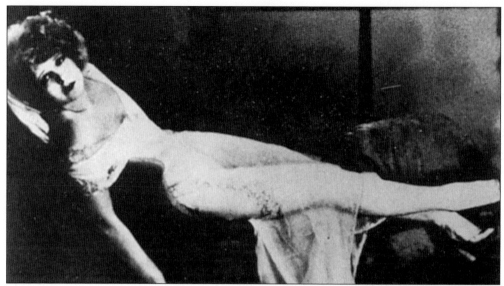

Doing for scanty nightgowns in the 1920s what Lana Turner did for sweaters in the 1930s, Clara Bow's sparkling eyes, stylishly bobbed hair, and cupid bow lips worked their magical charm on movie audiences everywhere. Clara was known as the "IT" girl and became among the few silent film stars to survive the transition into talking pictures. Many of Hollywood society's grand dames attempted to ignore Clara, feeling Miss Bow's behavior was shameless. Bow married cowboy actor Rex Bell and, in the 1920s, moved to his cattle ranch about 16 miles from Nipton, CA. Bell (shown below) drove his cattle to Nipton for shipment by rail to market. Clara Bow was often seen herding the family's beef during roundups. She had a favorite room (available still) in the Old Nipton Hotel.

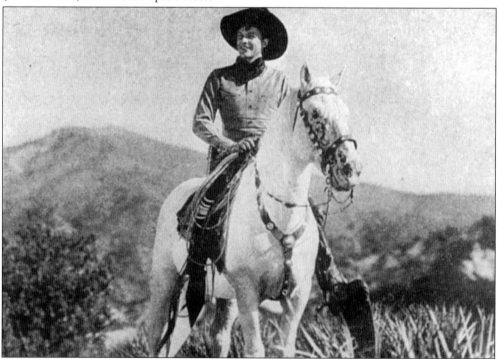

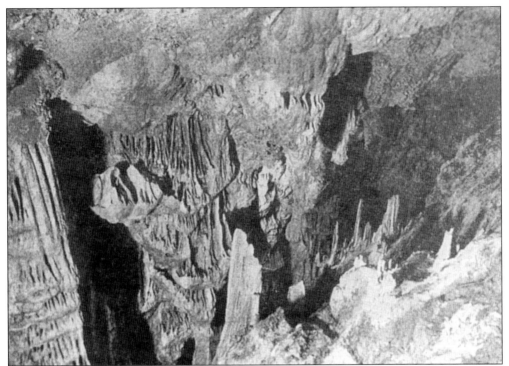

Mitchell Caverns is a part of the California Recreation Area in Providence Mountains, Mojave Desert. In visiting these limestone caves, one will see many stalactites, stalagmites, cave spaghetti, cavern coral, and more. The temperature remains a constant 65 degrees at all times. Touring the caverns is permitted. Additional information can be found by calling (760) 928-2586.

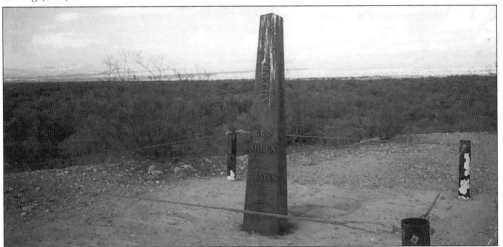

In 1873, five years after the Civil War and 23 years after California joined the Union, A.W. Von Schmidt erected a monument. The purpose of California Registered Historical Landmark 859 was to show California's and Nevada's state line in the Needles area. Schmidt's survey took from 1872 to 1873 to complete their officially recognized oblique state line boundaries survey. Erring slightly, Schmidt's placement was corrected to the present line, 3/4 of a mile to the north from where he had placed a cast-iron column.

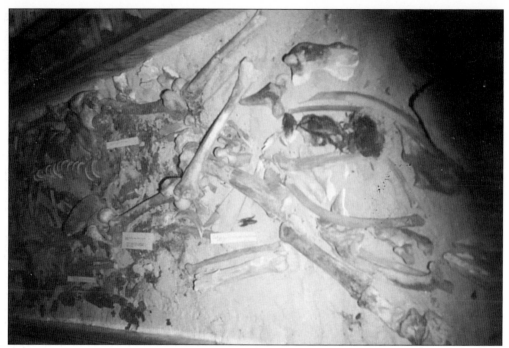

The "Headless Horseman," as this display states, are the remains of a conflict that occurred in January 1851, four months after California became a state. Nearly two dozen cowboys were pursuing 40, well-armed Ute tribesmen fleeing to Utah with stolen San Bernardino Valley horses. After riding for two days from Victorville, near Death Valley, the cowboys were ambushed by the Utes. One rider was killed and stumbled from his horse, which was apparently also shot. In 1965, a ranch worker in Yermo found human bones atop a decayed horse. Extensive investigation soon followed the discovery, and the facts pointed to the Headless Horseman being the one reported lost in the pursuit. The remains of the cowpoke may be seen and studied at the Mojave River Valley Museum, Barstow Road and Virginia Way, Barstow.

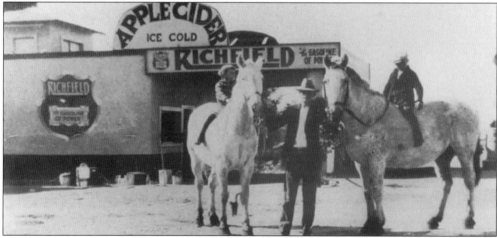

Posing in front of Oro Grande's Richfield gasoline station in the late 1920s are Fred Sr., Fred Jr., and George Berger. The Bergers used these work horses as a team to till the soil turning the desert green. When was the last time you had a drink of ice cold Victor Valley cider? (Courtesy Fred Berger Jr.)

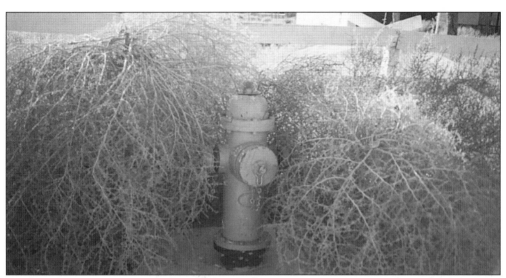

Introduced into America from Russia in the 1870s, Russian thistle seed escaped detection in what was believed to be pure flax seed. Within a dozen years after this uninvited sowing, a third of the United States and 13 Canadian Provinces were over run with this obnoxious weed. When mature, the plant breaks from its main root and follows the wind's whims, tumbling along and broadcasting some 50,000 descendant seeds. Called tumbleweed on the Mojave Desert, these bushes create serious safety problems, rolling into moving vehicle paths and piling up in bunches, becoming fire hazards. Dried thistle plants, when ignited, burn at an explosive rate. Seen here is an unusual scene, where tumbleweeds have rendezvoused with a fire hydrant, which might be needed to extinguish the tumbleweeds pyrotechnics.

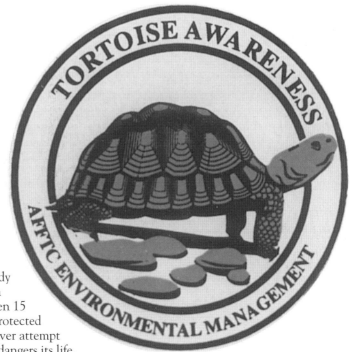

The Mojave Desert tortoise does well as it fights the environment to survive. After centuries of adapting to harsh and arid climates, this threatened species makes the most of the limited water and food supply to be had. Its sharp claws and strong legs provide the means for digging deep burrows in sandy places. Tortoises hatch from eggs and reach maturity when 15 years old. They are highly protected by law, and no one should ever attempt to pick one up. Doing so endangers its life.

After the making of Eden came a serpent, and after the gorgeous furnishing of the world came a human being. Hence the existence of the destroyers? Before man's coming, security may have been enjoyed, but how soon nature learned the meaning of fear and how instinctively she taught the fear of him to the rest of her children! Today, after centuries of association, every bird and beast and creeping thing—the wolf in the forest, the antelope on the plain, the wild fowl on the sedge—fly from man's approach. They know that his civilization means their destruction. (Courtesy Judge T.S. VanDyke, Daggett, CA, *c.* 1914.)

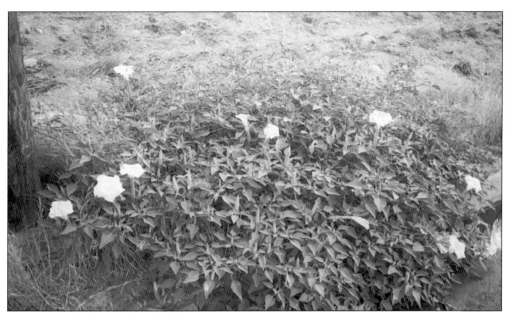

This Mojave Desert "no no" is called Jimsonweed. Its flowers, although beautiful, are best left alone. Also known as Datura, it is found everywhere on the desert. Trumpet-like white blooms, similar to Easter lilies, begin their life in the early part of the summer months. The mother plant is a spreading deep green vine with great stamina. Narcotics found in this dangerous plant produce vivid visions and hallucinations. Many deaths are caused experimenting with this "flower of death," and each year tells of more thrill seekers losing their lives from believing it will not happen to them. Other names for it are Angel's Trumpet and Moon Flower. American Indians long ago knew that using this beautiful flower brought blindness and insanity.

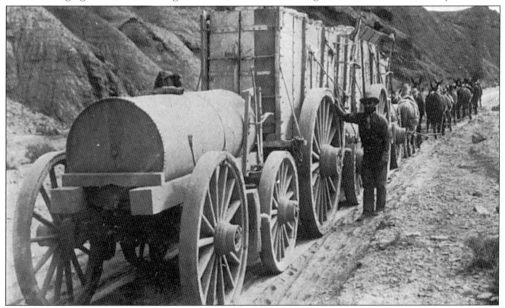

This 1890s photograph shows how borax was hauled between Calico and Daggett. In 1894, a steam-powered tractor named Old Dinah attempted to replace this method; however, nothing was more successful than mule trains.

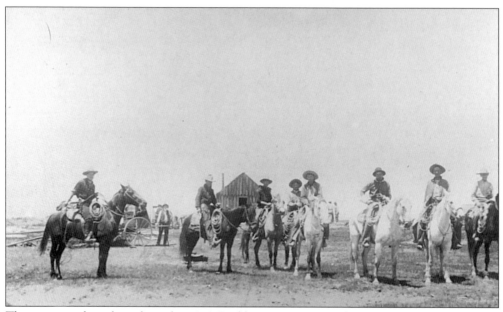

These mounted cowboys from the 1912 Buckhorn Springs Ranch are preparing for some cow poking (round-up). The ranch was on the Muroc Dry Lake, in the far western reaches of the Mojave Desert. Muroc derived its name from reversing the original "Corum" name (onetime owners). The change was for postal service reasons. Muroc is now Edwards Air Force Base. (Courtesy Mirl-Sarah Orebaugh.)

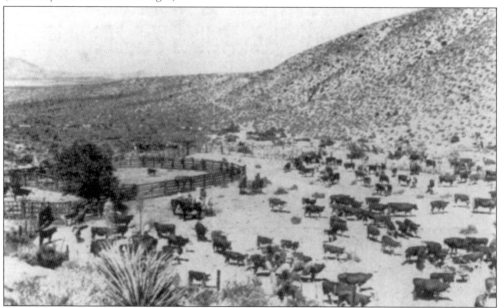

These cattle are branded with the Lazy K Guest Ranch's branding iron. Located in Hodge on Route 66, this "dude" ranch afforded guests ways and means on becoming a semi-cowpoke for $37.50 a day. City people would wear cowboy attire and yodel, having a Wild West time during the 1930s. Both Santa Fe and Union Pacific made stops for passengers at this property, which once belonged to Arthur Brisbane, an editor employed by William Randolph Hearst's chain of newspapers. (Courtesy Henry Jay.)

Mojave Desert trees and shrubs need plenty of root space to gather moisture since rain is scant, and each drop of water is vital for plant life. Shown here is the creosote bush (*Larrea tridentata*). This bush appears throughout the southwest and into Mexico and seems to have been planted by a plan. Normally, the creosote plant grows from 3 to 8 feet in height with dark olive-green leaves and blackish stems. It gets its name from the strong resinous odor it has, much like the smell of creosote. Desert dwellers have used creosote leaves for medicinal purposes for centuries. The author lived for eight years in Baja, CA, among the natives, who claimed drinking creosote sun tea would cure a cold in seven days. Otherwise, it would take a week.

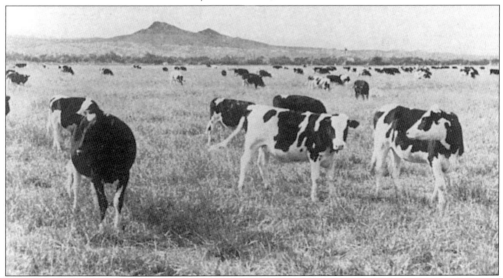

Helendale claims the distinction of being called the Emerald Isle of the Mojave. Cattle ranches and alfalfa growing have outstanding potential locally, amid a very favorable climate blessed with abundant water. These cows are grazing in 1965 on a 2,400-foot elevation field, where today lovely homes have taken over. In the 1960s, four dairies were milking daily. Few cows range here now, and home-style milk is as scarce as snowfall. (Courtesy Henry Jay.)

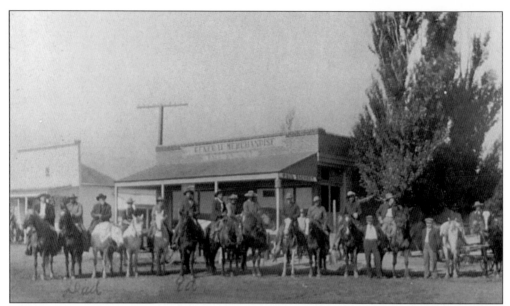

These cowboy dandies rode into Lancaster prepared to whoop it up. The occasion was July 4, 1905, or maybe, 1908. They posed in front of the General Merchandise Store, located on Antelope Avenue and Tenth Street. The riders were from the Robinson Ranch, Helendale, and they ranged their cattle as far as the Antelope Valley. (Courtesy Mirl-Sarah Orebaugh.)

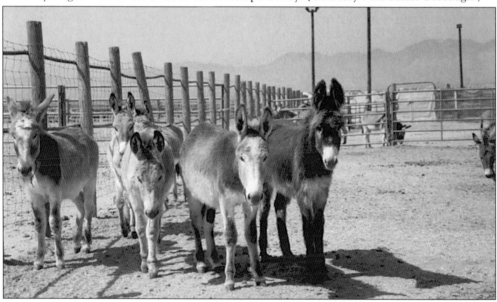

Burros are found most everywhere on the Mojave. These lovable, cantankerous, mischievous, and fascinating long-eared characters are fresh off their desert homes. Easily tamed, citizens can adopt these "pets" from the Bureau of Land Management. Abandoned by oldtime jackass prospectors when automobiles became affordable in the 1920s, these historic servants of man were turned loose to fend for themselves. During the gold rush period, burros were responsible for most of California's gold being transported. They were reportedly brought to the Americas on Columbus' second voyage. The critters seen here were awaiting a 1999 adoption at Ridgecrest, CA's BLM holding corrals. (Courtesy Gill Brewer.)

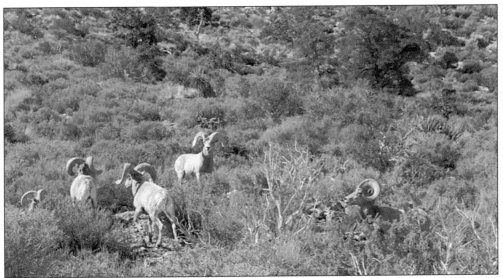

Wild bighorn sheep are seen here in 1997 above Lucerne Valley. Jack Baker, who took this picture, tells of this herd being well protected both by the law and by caring people. Because they are scarce today, it is now a treat to be able to see bighorns in their native habitat. They range and are seen widely over the Mojave Desert.

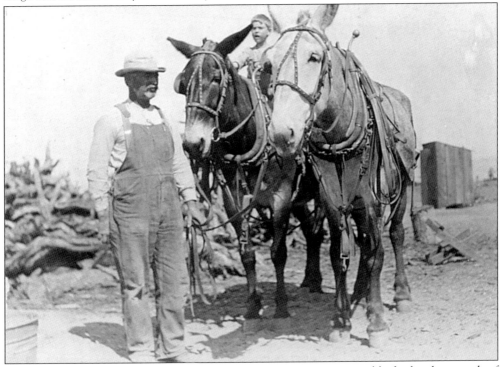

Never underestimate the power of a mule team. Mules were responsible for leveling much of Victor Valley. Once leveled, homes and farmlands began to blossom. This 1914 photograph shows Hesperia homesteader "Grandpa" Waggener leading his mules into another day of back-breaking labor. The homestead was located where Rancho and Kourie Way are now. (Courtesy Mabel Widney.)

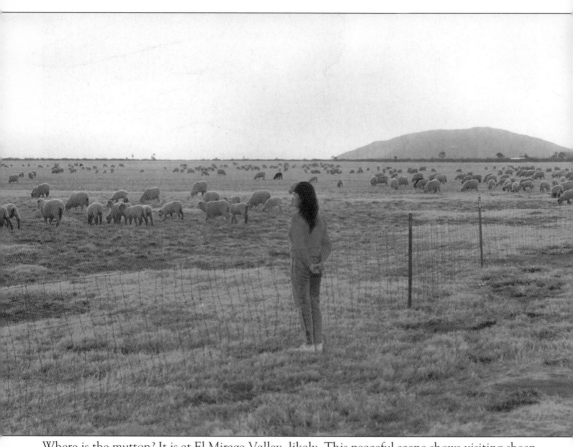

Where is the mutton? It is at El Mirage Valley, likely. This peaceful scene shows visiting sheep grazing where once vast flocks crossed here en route to the Mother Lode Country. Those 1849 sheep largely came from New Mexico and Old Mexico. Sonora exported 40,000 head between 1851 and 1853. Even famed American-Indian scout Kit Carson drove 12,000 sheep from New Mexico to California on a private money-making venture. And yes, those passive animals leisurely foraged their way north, while tasting El Mirage vegetation. (Courtesy Paul-Betty Davis.)

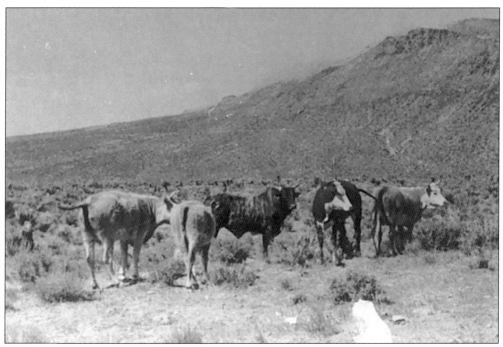

These cattle were roaming free on the Horse Thief Ranch in 1965. Feed on the Mojave was enough to put some weight on cows if not ranged too closely. This area is in the vicinity of Barstow. (Courtesy Mojave River Valley Museum.)

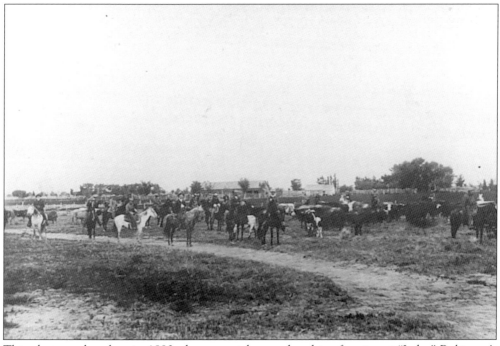

This photograph, taken in 1890, shows a cattle roundup drive forming at "Judge" Robinson's ranch in Helendale. His cows ranged for miles across the western region of the Mojave. (Courtesy Mirl-Sarah Orebaugh.)

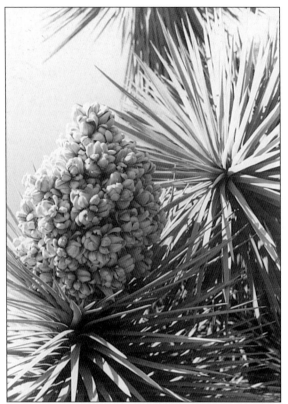

Springtime brings many bizarre forms of plant life to the Mojave. Here is a Joshua bloom looking much like a pineapple. Actually, the Joshua tree is a member of the Yucca family and has reached heights of 65 feet with 5-foot diameters. They usually grow in elevations between 2,500 and 5,000 feet and lean into the direction of prevailing winds. Minus a tap root, tree ages of several hundred years are common for this slow-growing Yucca Breviofolia. They only grow in America's western deserts, nowhere else! When pathfinder army officer John C. Fremont traveled California in 1844, he recorded seeing palm trees growing. Fremont's idea of what palm trees looked like is understood by naturalist Milt Stark, author of books and papers on Mojave plant life. Stark says Fremont called the Joshuas Yucca "palms," and that is where Palmdale, CA, got its name.

Totaling over 1,000 square miles of range land, vast numbers of cattle were moved far over the Mojave in the years clustered around the 1900s. This line shack rests in ruins on the Bob Older Ranch in Helendale. Within those adobe/cement shack walls, many a riding cowpoke found succor from the harsh elements of desert living. These shelters were placed several miles apart. Two of these 100-year-old cowboy emergency quarters still exist in ruins, while others were washed away in a 1938 flood.

This is all that is left of real estate developer Newt Bass' big cattle corral near the entrance to Fairview Valley. In the 1940s, prospective buyers of the Apple Valley property were brought here for a steak barbecue and sales pitch. The guests were transported from the Apple Valley Inn in a stagecoach now housed in the Victor Valley Museum. (Courtesy Myra McGinnis-Swisher Collection.)

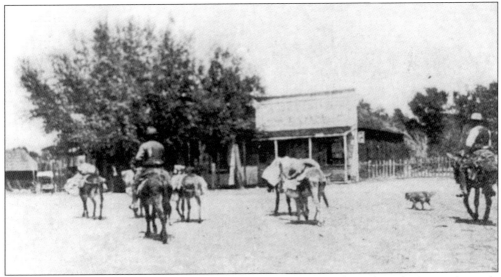

This picture shows the only manner of transportation for people and goods during the early 1900s. Mules, horses, oxen, and the ever-dependable burros provided the means to move heavy items. This photograph is believed to have been taken in Oro Grande around the turn of the 20th century. As with most pack trains in those days, one can see a faithful dog, with wagging tail in motion, tagging along as it approaches trees. (Courtesy Penny Morrow Collection.)

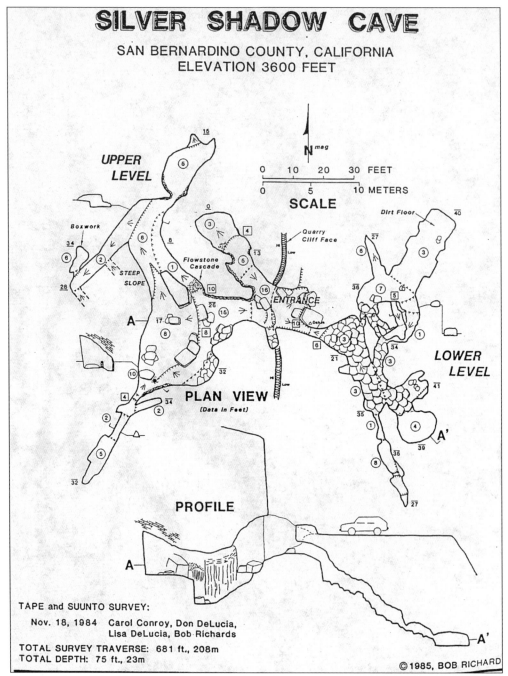

SILVER SHADOW CAVE

SAN BERNARDINO COUNTY, CALIFORNIA
ELEVATION 3600 FEET

UPPER LEVEL

N mag

| 0 | 10 | 20 | 30 FEET |

| 0 | 5 | 10 METERS |

SCALE

Dirt Floor

Boxwork

Quarry Cliff Face

Flowstone Cascade

STEEP SLOPE

ENTRANCE

LOWER LEVEL

A

PLAN VIEW

(Data in Feet)

A'

PROFILE

A

A'

TAPE and SUUNTO SURVEY:

Nov. 18, 1984 Carol Conroy, Don DeLucia,
Lisa DeLucia, Bob Richards

TOTAL SURVEY TRAVERSE: 681 ft., 208m
TOTAL DEPTH: 75 ft., 23m

© 1985, BOB RICHARD

Signs reading "No Trespassing" are posted in the vicinity of the Silver Shadow Cave. Discovered in 1951 by Nicholas Baxter, 14 miles north of Adelanto, the cave is actually two caves—one was named the Cathedral Room and the other Silver Smith. The elevation is 3,600 feet at the now-dynamited-shut entrance. Dozens of passageways run between stalagmites and stalactite formations. The Silver Shadow has been compared with Mitchell Caverns, also on the Mojave. (Courtesy Bob Richards.)

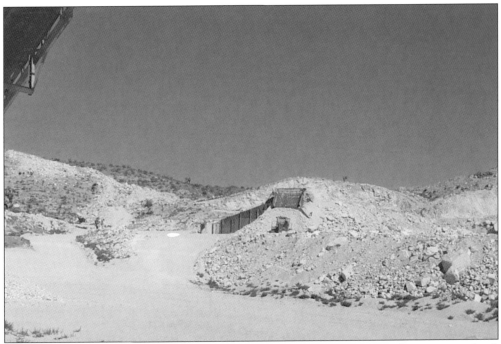

Seen here is the closed entrance to the Silver Shadow Cave, situated on private land. Trespassers are not welcome. Insurance costs to protect the owners would be astronomical, and dangers to exploring sightseers are ever present. Besides, most of the cave has been wrecked by vandals. (Courtesy Jim Doepke.)

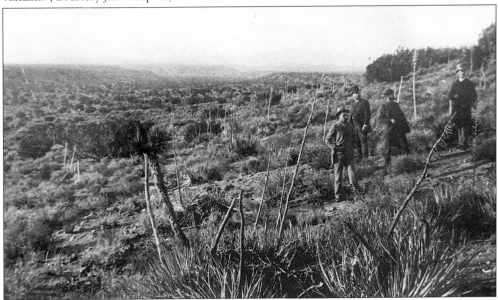

Potential land buyers in Hesperia are pictured here in the 1880s. They are considering purchasing mesa property for private use or commercial venture. Within a few scant years, large acres of Juniper trees were cut down, corded up, and railroaded to Los Angeles as firewood for bakery ovens. Juniper wood burns with an intense heat. The selling price for a cord of this tree was $5.

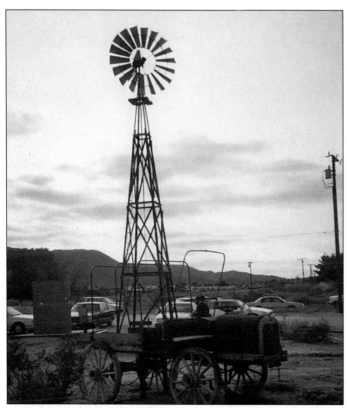

Mojave Desert humor may be seen in studying this view of a machine at Twenty-nine Palms' Museum. Whatever it was and however it was used remains a desert mystery. The nearby twirling windmill shows pride in the fact that these blessed fuel-less "spinners" pumped life-giving moisture freely. Terribly thirsty people, plants, and animals, back before the desert imported Colorado River water, depended mightily on the wind's whims—whims that either turned the mill fans or hindered their movement.

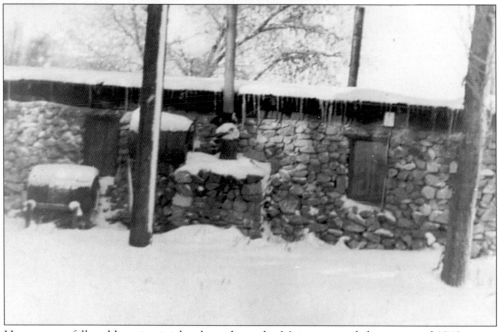

Heavy snow fall and hanging icicles throughout the Mojave turned the winter of 1949 into a weather-breaking event. Here is the east side of a Turner Ranch Road home, with proof around it to record the weather of January 4, 1949.

This is the Bell Mountain area, so named because of a bell-shaped hill dominating the vicinity. Travelers along Interstate 15, north of Victorville, are familiar with the large, bell-like rise reaching hundreds of feet into the sky. Noted for gold mining (Sidewinder Mine), it also boasts having, at one time, the world's second largest kiln for making cement. (Courtesy Gladys Butts.)

Kin to the cuckoo bird, *Geococcyx californianus* (roadrunners) are quick-witted and are seldom seen in pairs. Their diet consists primarily of lizards and insects. Considered good luck to have around, they can zoom along at 18 miles an hour. They are true members of the Southwest and the Mojave Desert.

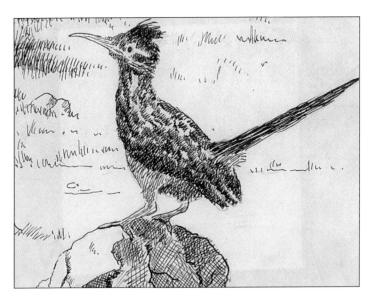

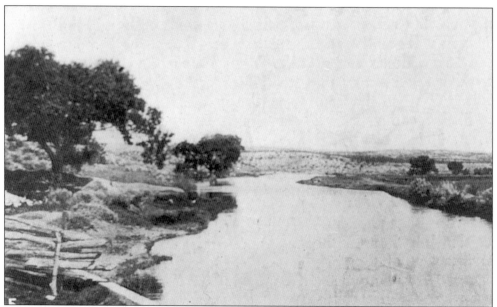

This 1925 picture shows the Mojave River flowing north from Hesperia in an almost flooded state. One old-timer in Victorville wrote of seeing the Mojave River a mile wide during the 1885 flood. Although in most places Mojave River water appears gone, underground water flows year-round just feet below dry sand. (Courtesy *The Joshua Tree*, 1926.)

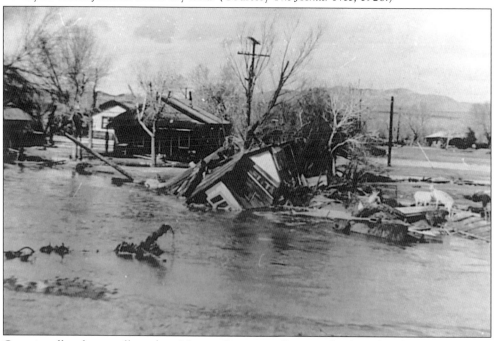

Occasionally, the usually sedate Mojave River overflows its bank and rushes north on an assaulting journey. This is the end result of one such rampage during the winter of 1937–38. Three massive rain storms came days apart into southern California, wrecking havoc throughout the Mojave Desert. Northeast Victorville suffered heavy loss of property from the deluge, as seen here. The last such downpour occurred in 1878.

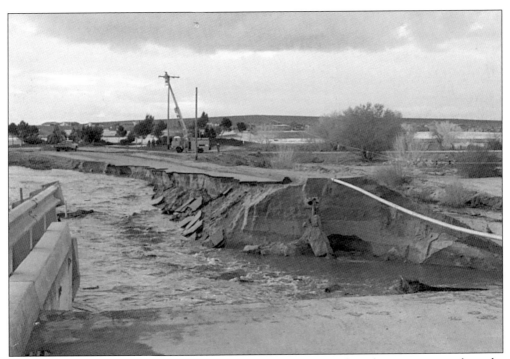

Reports say the Mojave River overflowed its banks once, with rushing water a mile wide. Through the years, severe water damage to real estate and a loss of life have taken a heavy toll on riverfront occupants and trade. This picture was taken shortly after the flood of 1938, when the upside-down river, the Mojave, went berserk—again.

Scenes and views of El Mirage Valley were observed by both "Scout" Kit Carson and "Pathfinder" John C. Fremont in the mid-1800s. El Mirage Valley is 10 miles square and has a 3,000-foot elevation. It is situated 12 miles west of Adelanto. Alfalfa ranches, dairies, quiet homes, and a tiny "downtown" section add to its charm. The dry lake here provides off-road recreation facilities for both vehicle and aircraft enthusiasts. There are about 700 people living in El Mirage Valley year-round. (Courtesy Paul-Betty Davis.)

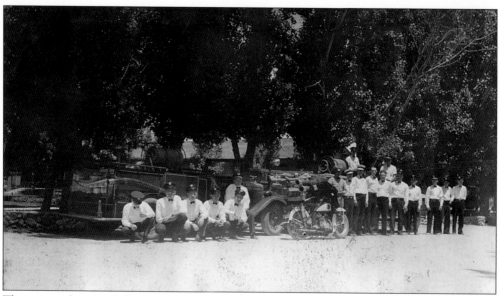

This rare and unusual photograph shows Victorville's motor cop and firefighters posing beside their trucks and motorcycle. The picture was taken in 1936, but little else is known about it. (Courtesy Thelma Anthony-Swisher Collection.)

Joshua trees grow only in the Mojave Desert region and vicinity. These Yucca family members live for many years and are very slow to mature.

Miss Flossie Philips, a hard-working and hell-raising wildcat of a woman, joined seven other fille de joles (ladies of the evening) at the Owl Hotel. Chased out of her West Virginia hometown by lawmen, this red-haired lass was popular with all the miners digging near by. One posted sign in Red Mountain reads, "While the men mined silver, they (the girls) dug for gold." The Owl Hotel opened in 1918 and put all of the girls out of work by closing in 1954. (Courtesy Ed Lemoine Collection.)

Instead of leading to the basement, these doors opened into hidden tunnels. The Owl Hotel, where rooms were available for a few minutes only, was one of Red Mountain's leading fun houses. Here, eight ladies of the evening joined lonely miners in age-old games. Situated as it is, on the Kern/San Bernardino County lines, law officers were seldom around. Occasionally, an effort would be made by officials to halt the affairs going on at the hotel; however, somehow, word preceded the deputies arrival. Within minutes, all the working girls were safely tucked away below the hotel's bar. These subterranean passages were also used to store untaxed liquor. Selling such amounted to a very handsome profit in barroom sales. One never suspects basement doors could be intriguing, but in a few cases, they are!

"Recreation" could well be another name for El Mirage Valley. Seen here are various sports enthusiasts doing their things. Beside off-roading, they play with land sailors, ultra lights, parasails, kites, gyrocopters, hang gliders, and model airplanes and rockets. In the 1930s, automobile racing fans selected El Mirage Dry Lake as a site for monthly events. (Courtesy Paul-Betty Davis.)

Burros range throughout the Mojave Desert and thrive on native plant life. They do have enemies and dim-witted humans top the list.

Four

UP, UP, AND AWAY

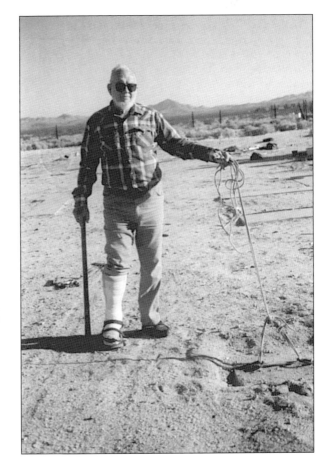

The author is shown here in 1999 at the forgotten and long closed Lenwood Airport holding a tie-down line that once held Ford Tri motor passenger airplanes in place during Mojave Desert winds. A major passenger commercial landing field in the 1930s transcontinental federal air program, Lenwood, like Hesperia, was one of many such airfields operated by the federal government at that time. (Courtesy Gill Brewer.)

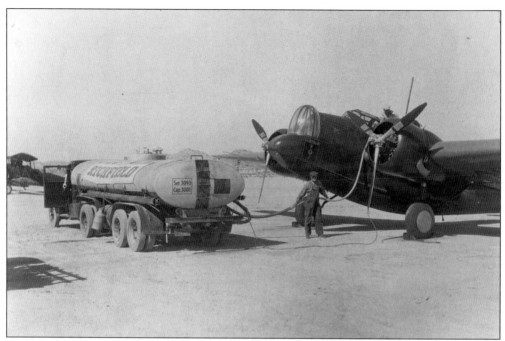

A B-12 Army Air Corps bomber is shown here being refueled. These early aircraft often visited the Muroc Airfield during flight training. Known as the Muroc Gunnery Camp in 1936, the dry lake is now Edwards Air Force Base. Note the old B1 fighter plane partially visible to the far left in the photograph, beyond the Richfield (Arco) gasoline tanker. B1 fighters were still being used in the beginning of World War II. (Courtesy Edwards AFB History Dept.)

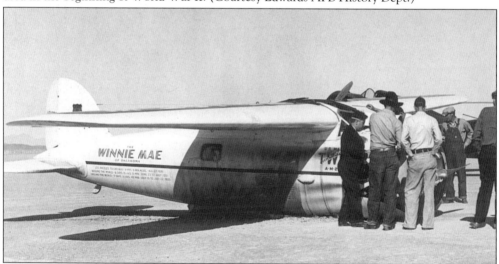

Famed 1930s aviator Wiley Post was forced to make a deadstick landing near Muroc Dry Lake on February 22, 1937. Minutes earlier, Post flew from Burbank Airport hoping to be first in a stratospheric transcontinental flight. His wings were a highly modified Vega (Lockheed), named *Winnie Mae*, after the owner's daughter. Prior to this attempt, saboteurs poured emery dust in the external supercharger, causing the crash. On July 1, 1931, Post and another pilot set a speed record circumnavigating the globe in 8 days, 15 hours, and 51 minutes. (Courtesy Edwards AFB Historical Dept.)

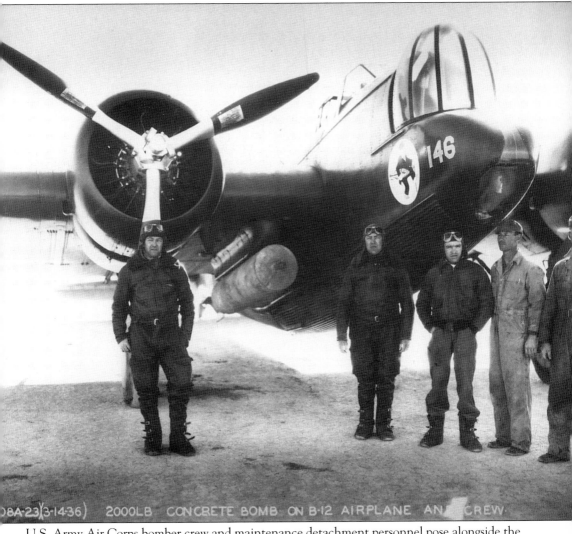

08A-23(3-14-36) 2000LB CONCRETE BOMB ON B-12 AIRPLANE AND CREW.

U.S. Army Air Corps bomber crew and maintenance detachment personnel pose alongside the then-popular B-12 bomber. This late 1930s photograph shows a cement bomb mounted on the airship, which was made by soldiers stationed at the Muroc Airfield. The dry lake region, now known as Edwards Air Force Base, was once a raceway for 1930 hot rodders and their A-V8s. (Courtesy Edwards AFB History Dept.)

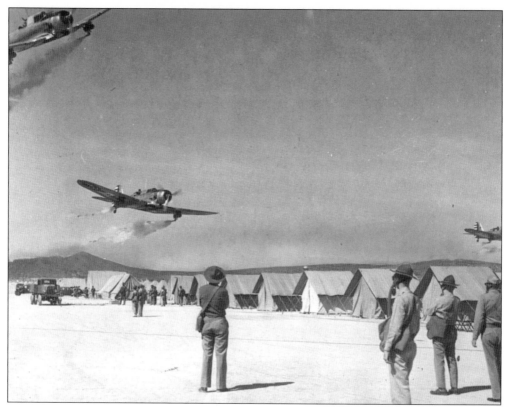

During the month of May 1937, more than 2,000 support personnel, 400 pilots, and 300 aircrafts came together at the Muroc Airfield. This coming together was for the largest war game training then ever held. The maneuvers simulated the role fighter planes would play in defending a large metropolitan area. Whatever was considered to be "the" large metropolitan city was not named; however Hinkley, near Barstow, was not likely the one. (Courtesy Edwards AFB History Dept.)

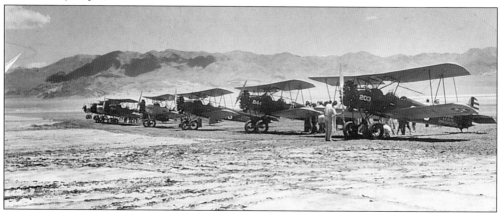

U.S. Army Air Corps fighter planes from March Field, CA, are shown participating in 1935 maneuvers. Flights of army fighters once rendezvoused across the Mojave Desert on training missions. These "ships" are parked at Searles Valley, near the Trona Pinnacles Recreation Lands. Today, the Air Force still races across the Mojave Desert; however, they seldom visit the tiny communities they once dropped in on.

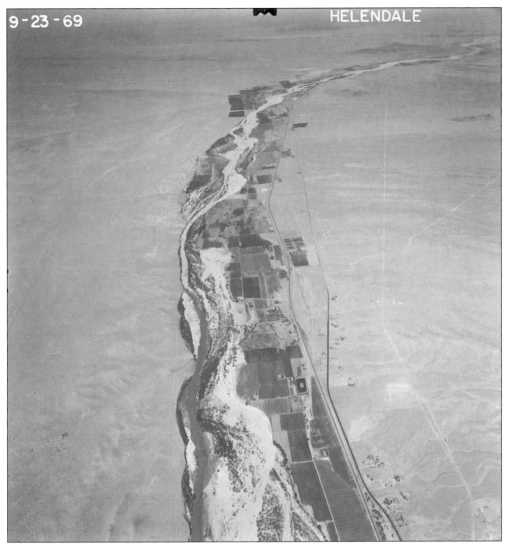

Hidden in this September 1969 crow's-eye view of Helendale are the Mojave River and Santa Fe rail tracks. The winding roadway running alongside in a north/south direction was Route 66 at one time. Today, it is National Trails Highway. (Courtesy Bob Older Ranch.)

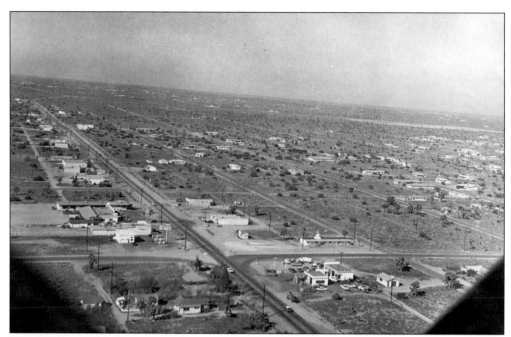

The late Myra McGinnis was both a top-notch photographer and news reporter. While dangling precariously from a small, low-powered aircraft in 1965, Myra photographed this Hesperia scene where Third Avenue and Main Street met. It appears that the Gulf service station, now owned by Shell Oil, was advertising gasoline for 31¢ a gallon. That is $1.14 less than today's Shell Oil pricing on the same corner. (Courtesy Myra McGinnis.)

Shown here are various forms of cactus found in the Mojave Desert. Many kinds can be seen growing close together to survive. Most have thorns and needles—ouch!

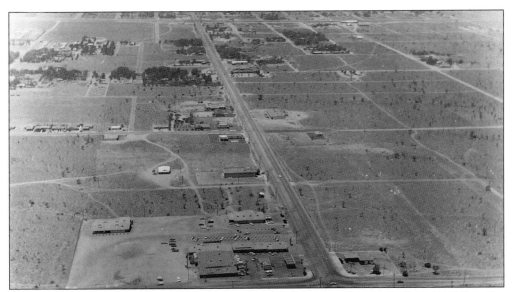

This aerial picture, taken in 1965, shows Hesperia on the move. Seen in the lower middle is the intersection of "I" and Main Streets. Here is how things were in the Victor Valley while Los Angeles suffered through the Watts chaos. At the time, television was greatly limited for viewers on the high desert (and some thought that a blessing).

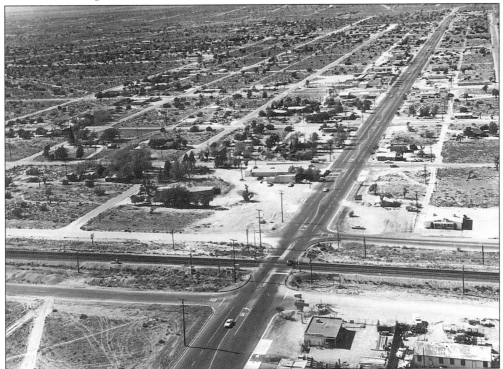

Showing steady growth, this 1967 bird's-eye view of Hesperia was taken before the railroad bridge came into being. Main Street is the wider paved roadway carrying eight vehicles. Santa Fe and Union Pacific trains rolled over the tracks, as seen about a quarter of the way up from the bottom of the picture. (Courtesy Photographs by Myra.)

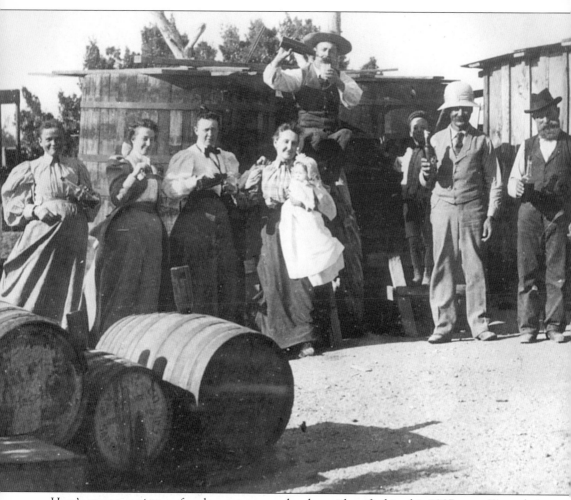

Here's a strange picture, for almost everyone has been identified in this 1887 pose. From their appearances, one might believe the whole group is "pie eyed" from overindulging in grape wine. Seen are members of Hesperia's Sefton Ranch, famous for its homegrown red wine, which sold for 50¢ a gallon. From the looks on these folks' faces, perhaps the wine was selling for 25¢ that day. From left to right, the revelers are Mrs. Gaynes, Stella Mitchell, Minnie Heffner, an unknown baby, Maude Golding, Elias A Heffner, Louie J. Heffner, Henry Johnson, and Mr. Gaynes. Henry Johnson appears to have had a head start over the others, baby and boy excepted.

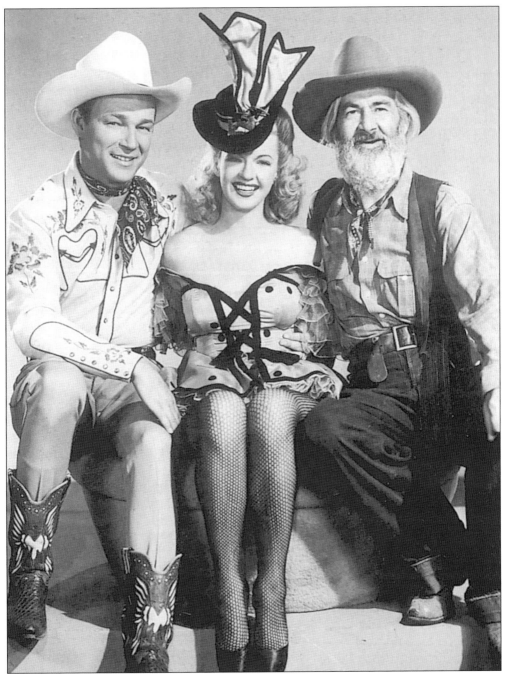

Western movie stars and longtime Apple Valley residents Roy Rogers (1911–1998) and Dale Evans (1912-?), husband and wife, pose here with co-star "Gabby" Hayes (1885–1969). Rogers spent a lot of time filming movies on the Mojave, and eventually made his home in Apple Valley. Roy rests in the Sunset Hills Memorial Park, about 8 miles from where Dale Evans Rogers keeps busy in many worthwhile projects. "Gabby's" spirit likely is still sniffing amid the cactus and sage brush he loved so well in his past life. The Roy Rogers and Dale Evans Museum in Victorville is a "must see" for fans of Westerns.

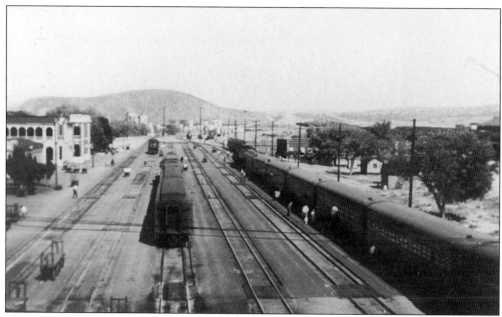

The year was 1940, and the place was Barstow's famous train station. Travel by train was the way to go back then, and Harvey House restaurants, like the one on the left of the yard's tracks, made traveling a delightful adventure. Within one and a half years, this easy scene would be rushed as World War II trains served the nation with full steam up. One conductor, "Duke" Atwell, never took a day off during the entire war. (Courtesy Chard Walker Collection.)

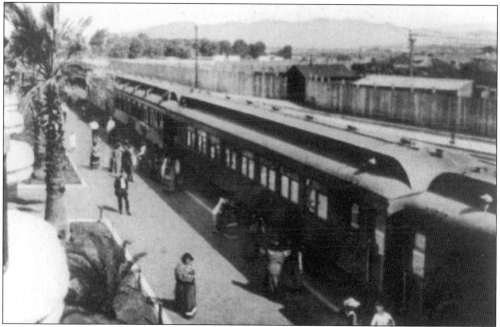

Santa Fe's Limited waits at Needles, CA. American Indians sold pottery, baskets, rugs, and other crafts to passengers from the nearby sidewalk. During the 1930s, travelers took time to see things and chat with strangers. Many Mojave tribal members were employed by Santa Fe in the Needles train yard. (Courtesy Maggie McShan-Needles Museum.)

Building materials were scarce on the Mojave Desert during the late 1890s through the early 1920s. Pictured here are cabins constructed from railroad ties and roofed by flattened tomato cans. These prime desert dwellings still battle the Mojave's jarring weather and continue to fulfill their purposes as a shelter. Snakes, often a problem, would pass through knot holes in rough lumber to enter these desert chateaus. Wary residents would flatten tin cans to cover the openings and would likely sleep better. (Courtesy Gerald Freeman.)

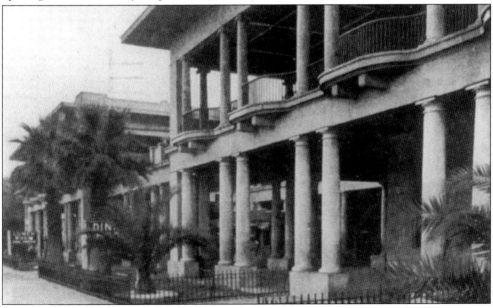

Built in 1906 and 1907, the El Garces train station was a major stopping point for Santa Fe trains. This beautiful building closed in 1949, and now, in 1999, strong local efforts are afoot to re-open the treasure. The Harvey House Restaurant, shown here, served all in grand style. Needles boasts having the El Garces and an entry point into the Mojave Desert and southern California. (Courtesy Maggie McShan-Needles Museum)

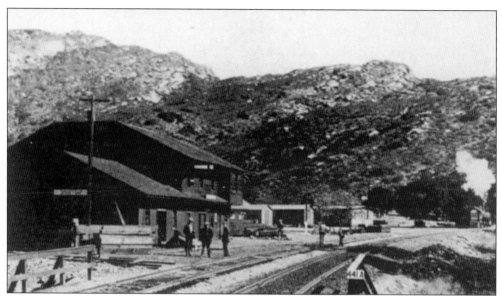

It started before 1923, when cowboy actor Tom Mix thundered across the world's movie screens atop Tony, the wonder horse. From then on and continuing today, movie filming throughout the Mojave Desert has supplied true desert locales to people living in far-off lands. Cowboy greats like William S. Hart, John Wayne, Roy and Dale Rogers, Errol Flynn, Randy Scott, Gene Autry, Smiley Burnette, and many others can be viewed visiting the Mojave Desert in films. Occasionally, movie watchers can recognize the desert location then being shown on the screen. Victorville's long-gone train station turned into "Smoky Gap" for the movie *Sand* in 1919. (Courtesy Seaver Center for Western History Museum of Los Angeles County.)

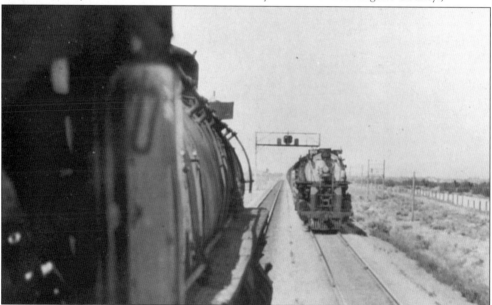

Chard Walker, noted railroad author, took this picture in 1947 from inside a steam engine's cab. These engines and trains are Union Pacific property, passing each other west of Hesperia. It shows the left-handed operation that once existed between San Bernardino and Victor Valley. (Courtesy Chard Walker Collection.)

96

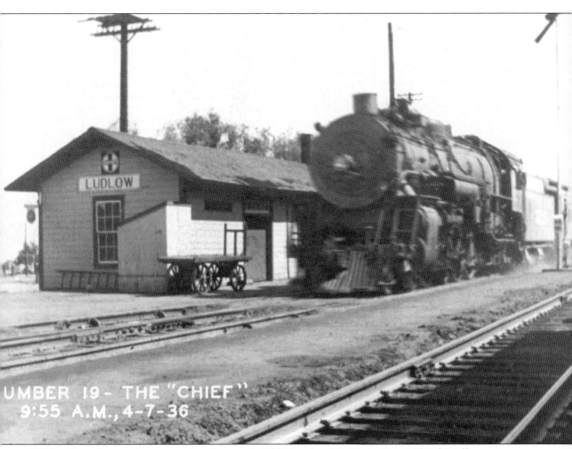

UMBER 19 - THE "CHIEF"
9:55 A.M., 4-7-36

With railroad semaphore arm signals raised, Old Number 19, Santa Fe's "Chief," rolls to a stop. This 1936 photograph was taken at the Ludlow train station, where a Railway Express Company's baggage wagon can be seen alongside the resting engine. During the heyday of railroading, baggage wagons stood by meeting all arriving trains. A collectors item now, these weathered and beat up "carts" sell for hundreds of dollars, and lucky is the buyer, for there are few REA wagons left.

The Santa Fe station at Needles boasted having a leading Harvey House restaurant and a top-notch hotel, El Garces, named after Padre Garces, who passed through this area in 1776. This photograph shows "Harvey Girls," who served delicious meals with dignity and smiling faces. The men seen here were typical of those who courted and married many of the waitresses during the 1930s and 1940s. (Courtesy Maggie McShan-Needles Museum.)

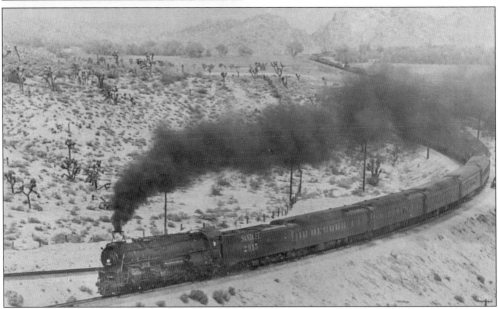

Santa Fe train number 23 is seen westbound with a 4-8-4 engine (the numbers indicate there were four small wheels at the front of the engine, eight large wheels as drivers, and four more small wheels under the engine's cab). In the background, an eastbound freight train is visible approaching Victorville through the Upper Narrows. This remarkable photograph was taken in 1952 on the upgrade track between the Upper Narrows and Hesperia. (Courtesy Walker Collection.)

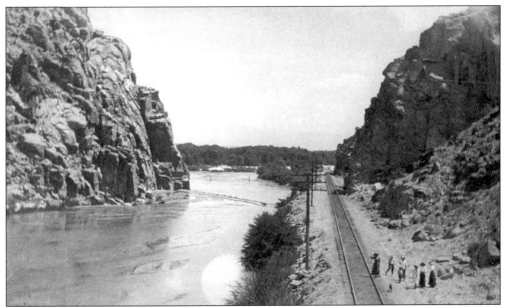

These are the Upper Narrows dividing Apple Valley from Victorville. The year was 1914 and the photograph shows a one-track railroad line. Mojave River water usually can be found here; however, the flow at that time seems extra busy. An American-Indian legend says that 1,400 years ago, a thunderous volcanic explosion occurred near Newberry Springs involving Mount Pisgah. This eruption shook the earth violently, causing a deep fissure in a rocky ridge, shoring up a large lake. Within minutes, the lake's water pressure forced an ever-widening opening in the fissure, and the birth of the Mojave Upper Narrows had begun. (Courtesy Myra McGinnis Collection.)

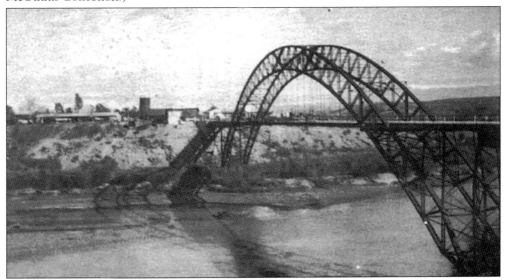

The Old Red Rock Bridge, sometimes called the Arch Bridge, was built in 1916. It crossed the Colorado River between Needles, CA, and Topock, AZ. This crossing was the first Route 66 bridge erected. Closed to traffic in 1950, it now supports a commercial pipeline and is regularly maintained. Today's traffic rolls over the river on Interstate 40's more modern overpass. (Courtesy Maggie McShan-Needles Museum.)

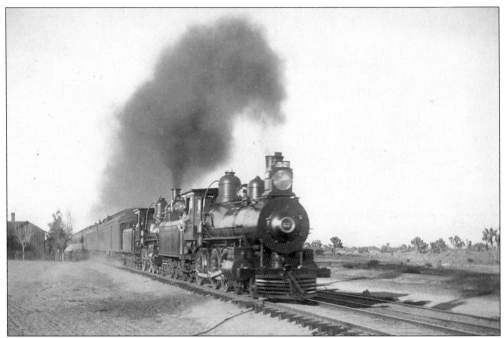

This tattered and torn 1890s photograph shows double engines pulling a Santa Fe train across Victor Valley. Research points to the locale being alongside what was once Santa Fe Road, near what was then the Hesperia Hotel. Two engines were needed to pull longer-than-usual train loads, and to brake them while descending through the Cajon Pass.

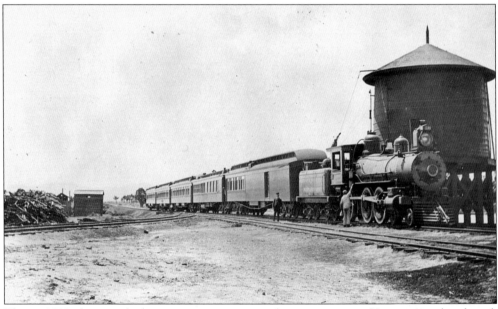

This c. 1900 photograph shows a passenger train taking on water in Hesperia's railroad yard. Juniper wood from Hesperia's wooded mesa can be seen piled high on the left near a track shed. Juniper kindling burns slowly and intensely, making a fine fuel to turn water into driving steam. The first rail car behind the engine and fuel carrier is for baggage. Money, mail, Sears Roebuck goods, and live baby chicks were also transported here.

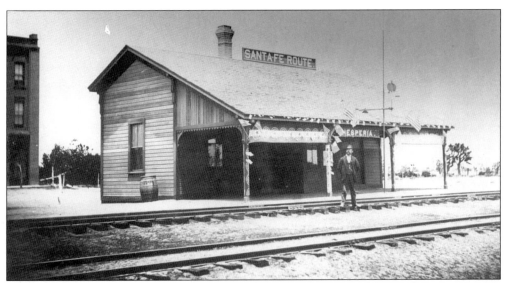

Mile post 45.1 was the sign between Barstow and Hesperia's moveable wooden train station. Built on runners in the 1890s, this 15-by-20-foot station belonged to the California Southern Railroad, later the Santa Fe Railroad, and served most of the needs of early Hesperia, both in bringing people and goods. It was moved from time to time, as photographs show it sitting in several locations. In 1952, Hesperia's first and last train station was rolled north to Victorville, where, in time, fire consumed it.

Bright-eyed but not bushy tailed, a desert rat is busy eating a treat in this Bill Bender drawing. The nearby cactus has been wisely passed—native intelligence likely dictated such.

This upside-down photograph is dated May 1890. Written on the picture's back is "Party on Mohaja River." This scene is near the tiny village of Oro Grande and from the private collection of the late Penny Morrow (1885–1985). Morrow was three years old when arriving in Oro Grande. He was the youngest of four brothers and, in later years, was known as Mr. Oro Grande.

Six

MILES AND MILES
OF MILES AND MILES

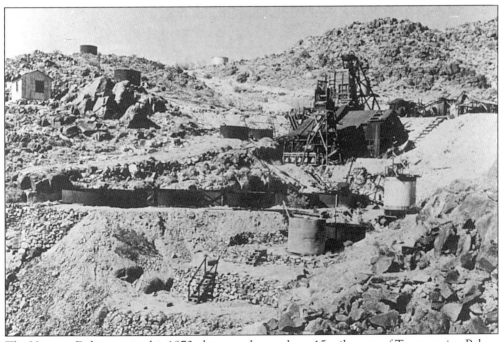

The Virginia Dale mine in this 1873 photograph was about 15 miles east of Twenty-nine Palms. Gold was found nearby, and a small stampede of prospectors prowled the area, finding rich ore and loose gold. Records show two men filed the Virginia Dale claim in 1885. This filing was likely a relocation of the above earlier mine. Some say that its name stems from the first child born there. (Courtesy Charles Radar.)

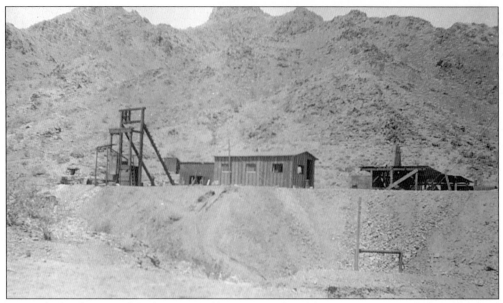

Located 25 miles east of Amboy, near old Route 66, the Vulcan Mine was worked until around World War II. Currently, someone is again sifting through old trailings in search of pay dirt. Gold-bearing quartz ore was mined here and milled on the site. These photographs were taken in 1933, when members of the John Muir family joined with eight men in working the steady paying but small profit diggings. (Courtesy Walter Muir.)

Ever wonder what a mine's entrance looked like before entering into its tunnel? This scene shows the Tropico Gold Mine shut down and boarded up. When the price of gold dropped lower than expenses, no one could afford to stockpile ore and wait for increasing returns. Railroad ties were used generously to barricade Tropico mine's entrance point. The mine, so blocked, is awaiting Kern County's 1000-year birthday in 2866. A time capsule beyond the entrance holds secrets from our century. The Mojave Desert has bits and pieces of Los Angeles, Inyo, Kern, and much of San Bernardino Counties. (Courtesy Myra McGinnis-Swisher Collection.)

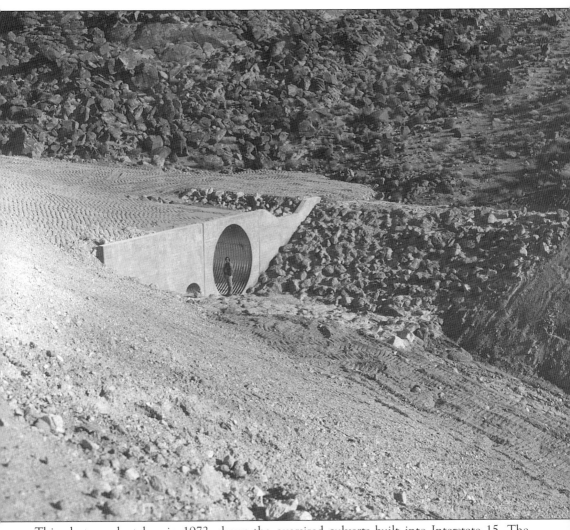

This photograph, taken in 1972, shows the oversized culverts built into Interstate 15. The California Division of Highways placed these special pipes under the freeway for easy passage of bighorn sheep and other wildlife of the Mojave, and, yes, animal rights are planned into California's road system.

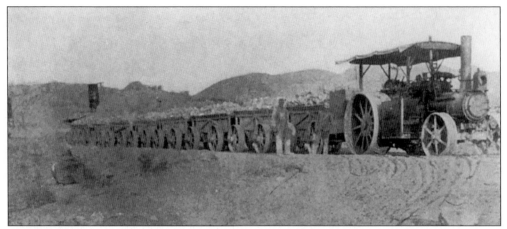

This lime rock train, c. 1910, was one of two trains being operated by the Golden State Portland Cement Company. These trains took lime rock from the company's diggings to its cement mill. Ninety tons of rock, six times daily, was the usual amount being supplied by steam trains, which, at the time, were slowly replacing mules, etc. There were eight lime quarries in Oro Grande that hired several hundred men when heavy with work. (Courtesy *Kingdom of the Sun.*)

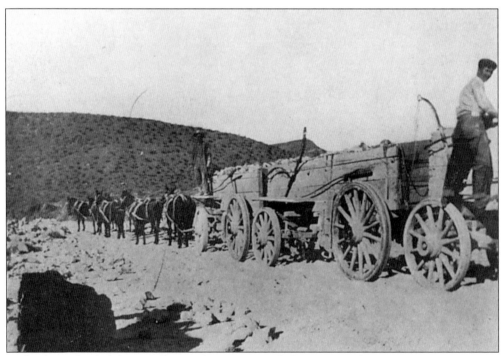

Mule teams hauled lime rocks in these wagons belonging to the American Beet Sugar Company. In 1910, that company had three such mule trains transporting lime from its Victor Valley quarries to the nearby railroad cars. Daily, this company shipped 250 tons of lime rock from Oro Grande. (Courtesy *Kingdom of the Sun.*)

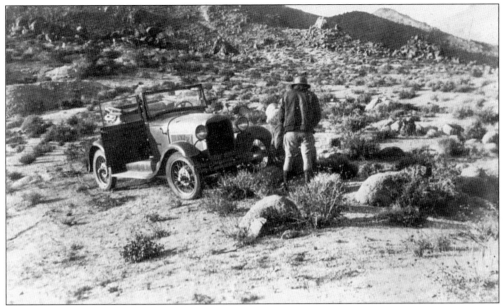

Fords, like this Model "A" coupe, helped to replace the trusty burro once motor vehicles became popular. Here, the late Hatton J. Martin is preparing to do mining on his Desert King ore claim on the Mojave Desert. One Depression-era "glory hole" he dug by hand brought him over $4,000 in a few days, although many other diggings resulted in only back-breaking labor. But, try to tell that to a true miner. (Courtesy Gordon Martin.)

Looking south down the 1800s Spanish Trail, the "X" mark shows where gold was discovered in 1849. Now called Salt Spring, the building on the horizon was built in the 1850s as part of the Salt Spring Mine's Camp. This location is on the fringe of Death Valley, 30 miles north of Baker. The water that runs here is bitter, and at times, stagnant pools can be 3 feet deep and 4 feet across. It has been said that the sands of Salt Spring's Creek have been worked by Mexican miners as far back as 1830, and this may be the case, as talk of it was still going on in 1898. Native desert American Indians attacked here in bold thrusts, attempting to drive off the unwelcome mining strangers, and once, they did! (Courtesy Emit Harder.)

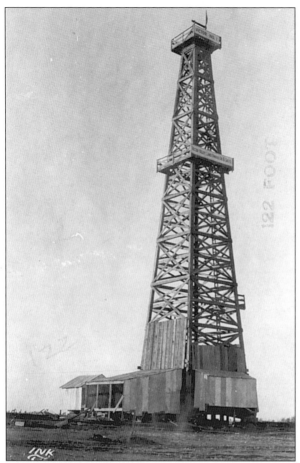

Instead of treasured "Black Gold," this 1924 oil well drilling proved to be a "no show" operation. The Victor Valley Land Owner's Oil and Gas Company's hopes reached down 1,720 feet between Phelan and Adelanto. All oil seeking on the Mojave failed to find commercial grade oil pools. (Courtesy Victor Valley Museum Association.)

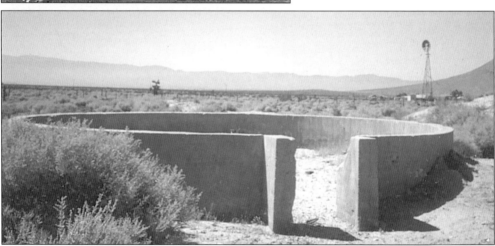

Hundreds of Mojave Desert mines extracted minerals as well as gold and silver in the 1940s and 1950s. One famous gold mine, the Sidewinder, used this arraste to grind gold rich ore before visiting a smelter. The Sidewinder is several miles east of Interstate 15 and about 7 miles north of Apple Valley. During the atomic bomb scare in the 1950s, the mine was used to store emergency supplies for evacuation purposes. (Courtesy Mrs. Roy Tate.)

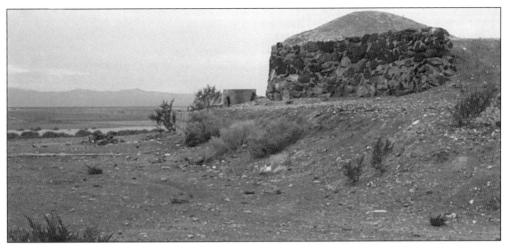

Very little has been recorded about this asbestos mine near Helendale. Located east of Lockheed's desert hush-hush project and known as a real estate developer's improvement area, asbestos was mined here steadily in the 1950s. With asbestos now a no no, the incombustible, fibrous mineral is no longer being mined here. Near here, there was an old cave with various shades of colored soil. Natives would mix this Mojave Desert offering with animal oil for facial paint used in warfare and ceremonies. (Courtesy Mirl-Sarah Orebaugh.)

The Apple Valley and Victorville foothills also supplied granite, a valuable building material. In the years immediately following 1900, the Fairchild, Wilton, and Gilmore Company hired at least 60 Swedish workers (who were imported from Wisconsin) to cross from their lodgings in Victorville over the Mojave River to where they were breaking boulders. At one point, several mischievous boys discovered a number of 5-gallon tin cans the miners used to prevent their shoes from getting wet when crossing the river, and drove nail holes into the can bottoms. Once in the river, the holes leaked and the angry victims arrived home with ill feelings about the suspects. There quarry shown here is located off Interstate 15 and Stoddard Wells Road. The city of Victorville can be seen in the distance. Incidentally, the tin cans were held in place knee high with wires by those seeking a dry crossing—sort of like a potato sack race.

Workers select choice granite columns from the vicinity of Lucerne Dry Lake. These 150-year-old pieces of rock were quarried by workers brought from the Eastern United States. Experts graded this Mojave Desert granite as being of the finest anywhere. Belonging to the BLM, modern-day workers are removing certain pieces for use as historical markers. Any other use and without permission is unlawful.

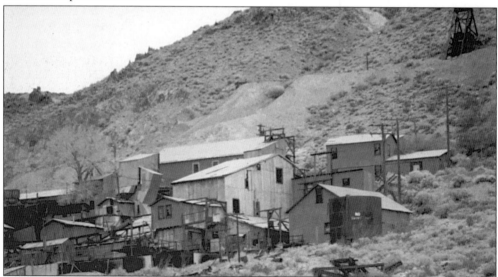

Not just another pile of pretty red rock, the lands around Tropico Mine netted from $6 million to $8 million worth of gold. It is known that American Indians were at Tropico, and Padre Garces (1776), Jedediah Smith (1827), Kit Carson, and John C. Fremont (1844) all passed by "Red Hill" in their travels. Rosamond, CA, bordering on Edwards Air Force Base, is near Tropico, which was so named in 1909 by investors coming from Tropico, now North Los Angeles, adjacent to Glendale. The mine, now closed, was located on a hillside, so the pull of gravity assisted miners moving ore to the mill. Living quarters for the mine's work force was below the mill, as seen here. (Courtesy Myra McGinnis-Swisher Collection.)

110

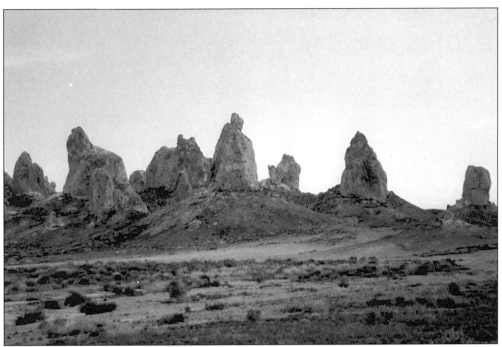

These two pictures show Trona's famed pinnacles, located on the southern shore of Searles Dry Lake, 120 miles north of Los Angeles. Numerous tall and majestic spire formations make up this natural masterpiece. One receives the impression that they are in a science-fiction atmosphere, especially on a moonlight night. The word "Trona" comes from one of the many minerals found in the dry lake. Besides Trona, the lake yields potash, soda ash, borax, boric acid, salt cake, lithium, bromine, and other salts. (Courtesy Gill Brewer.)

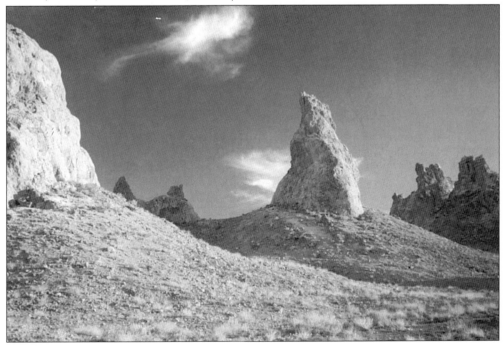

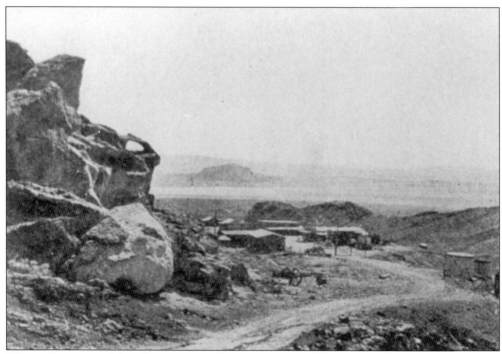

This 1900 view is of the silver mining village called Calico. The narrow road winds down into the main business area, which is 12 miles from Barstow. Now a park, Calico came into being in 1890 when LaFayette Mechem, following a horse thief into some hills, noticed an outcropping of silver ore. Reports indicate that $86 million of silver was mined here.

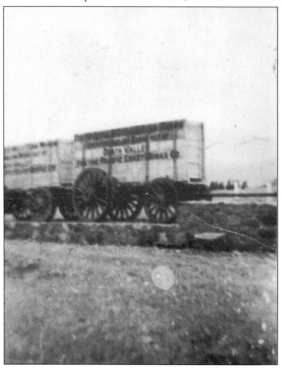

Daggett Blacksmith Alf built these 20-mule-team borax wagons during the 1880s, selling some and keeping others as investments. Additional wagons came from the township of Mojave, below Tehachapi Pass. This railroad town was the terminus for borax-loaded, 20-mule-team wagons, and after several days, they were returned to Death Valley with supplies. Filmed by the author in 1937 using 10¢ film, the resting spot for this wagon, built at Alf's, was at Furnace Creek Ranch in Death Valley. The picture isn't much, but 10¢ isn't either!

Apparently, the work was becoming confusing to the road maker at the far left of this 1920s photograph, or he was practicing for a 1930s job with the Works Progress Administration (only old-timers will find humor here). This road start became Interstate 40, after years of service as older named highways, one of which was Route 66. At the time this picture was taken, the passage here was the National Old Trails Road. (Courtesy California Dept. of Transportation, San Bernardino County.)

U.S. Army soldiers unload 600-pound bombs during 1936 maneuvers at Muroc on the Mojave Desert. The wool garments became real ovens when spring turned into summer. Airmen of today would call this back-breaking work cruel and unusual. (Courtesy Edward's AFB History Dept.)

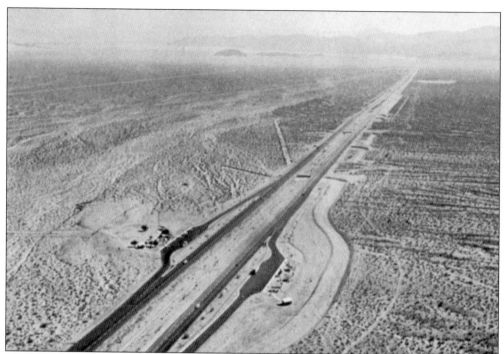

Halloran Spring's rest stops, for both directions of travel, are seen in this 1965 panoramic view of that area. Looking down the Baker Grade from here, one can spot Soda Dry Lake in the distance. Along this passage, California road crews took all measures to restore Joshua trees and native plants to their rightful place in the Mojave Sun. Placed with care, these arid flora wonders thrived and appear as natural as they once were.

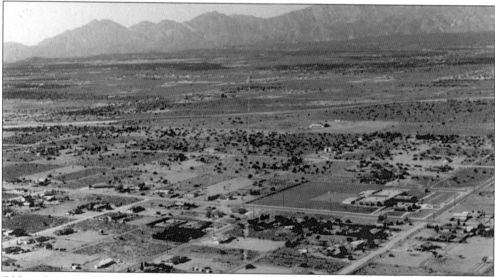

Old trails never die; they just fade away. And so will the 1860s John Brown diagonal road through Hesperia. This road ran between the Verde Ranch in Victorville and the Cajon Pass' old summit. The picture was taken in the 1950s, showing how the Brown passageway could still be traced. Airborne in 1993, one could still make out parts of this 139-year-old rutted, dirt path. However, more than three-quarters of the road seen here has now disappeared.

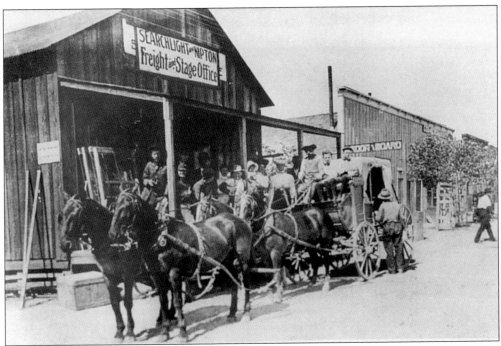

The Searchlight, NV, and Nipton, CA, Freight and Stage Company ran regular stages and freight between Searchlight and Nipton until 1927. This line took eastern Mojave miners, citizens, and cattle people back and forth from the San Pedro, Los Angeles, and Salt Lake Railroad stop at Nipton. The Union Pacific Railroad, in 1910, bought rights to the track, which is still in heavy use. Regular stage travel probably started and departed on time with train schedules. (Courtesy Gerald Freeman.)

The 1900 stage and mining road running between Nipton, CA, and Searchlight, NV, is shown here as it approached Nipton. Traveling 22 miles one way, these stage coaches were uncomfortable, dusty, and without conveniences of any sort. It took about an hour of rolling, bouncing, and jerking to reach ones destination, often in searing heat. And unlike Hollywood or television, there were no Wild West holdups on this stage line. (Courtesy Jerry Freeman, Nipton General Store.)

This 1946 aerial view of Apple Valley has Highway 18 marked for easier recognition (some light clouds obscure portions of the ground). It was during this time period that Newt Bass, with others, started touting this region, which he called "Happy Valley." In the mid-1940s, eight cars an hour rolled along the main roadway. The cars' occupants wondered in some parts where they were. (Courtesy Ellsworth Sylvester Collection.)

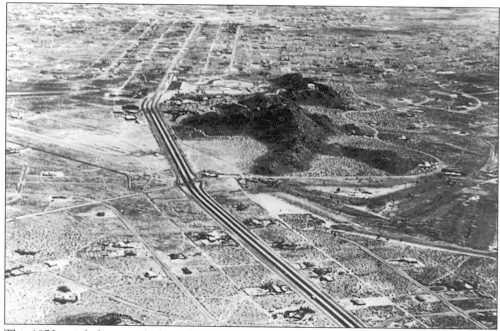

This 1970 aerial photograph shows how Apple Valley grew in 25 years. George Air Force Base veterans helped increase the population of "Happy Valley" as they retired from the service. Now a town, Apple Valley continues to have growing pains. The citizens here are very active and care a great deal about their beloved Mojave Desert. (Courtesy Ellsworth Sylvester Collection.)

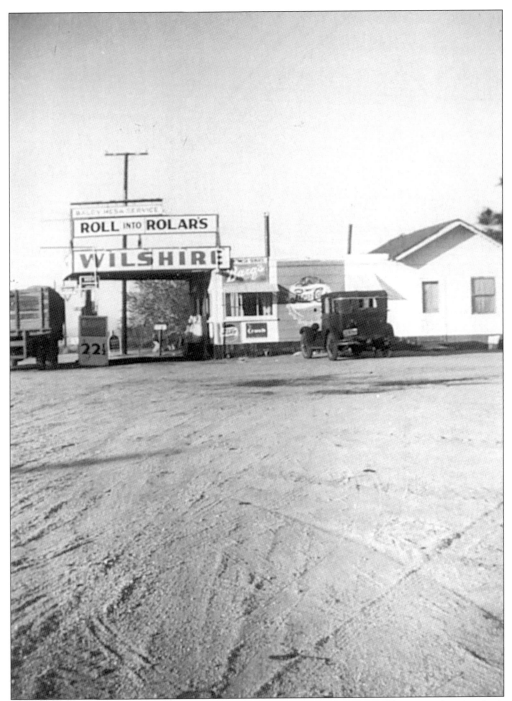

This 1930–40s gasoline station was located along Hesperia's Route 66, across from today's Outpost Truck Stop. Not called Hesperia then, the area was known as Balda-Mesa. The lunch counter inside Roll into Rolar's service station served true hamburgers, three quarters beef and one quarter pork. The brands of gasoline and oil have changed from time to time; Wilshire Oil was popular when this photograph was taken. (Courtesy Mabel Widney.)

Members of the transcontinental sign-posting crew of the Automobile Club of Southern California are shown doing their job in the Mojave Desert. Soon after the mileage and directional signs were erected, the 1914 National Old Trail Road location sported notations to aid harried motorists. First, in 1913, it was the Santa Fe/Grand Canyon/Needles Highway. One year later, that changed to National Old Trails Road. Route 66 followed that and Interstate 40 now enjoys top billing. (Courtesy Automobile Club of Southern California.)

Solid-tired dump trucks are shown here in 1922, hauling gravel between Cajon's Summit and Victorville. The gravel was being placed into the 16-foot roadway, 8 feet northbound and 8 feet southbound. This stretch of road was called State Highway 31C. It later took on other monikers, one of which was Route 66. The average wage for drivers of these behemoth rigs, in those days, was $1 an hour.

The arrow points to the former site of Bagdad, one of the Mojave Desert's "spots in the road." Never expected to grow much, a gasoline-garage business once stood here along with a Santa Fe Railroad water tank. The locale has many cross washes that were often troublesome to passing users of Route 66. Bagdad was between Amboy and Siberia, which is southeast of Ludlow. The photograph was taken in 1999, and the author notes no change here for decades.

The "Freeway of the West" is what some called it, but it was better known as "The Old Government Road." There is another moniker, the "Mojave Trail." The U.S. Army was using this centuries-old native trail beginning in 1861, during the Civil War. They established strong points, similar to forts, a hard days ride between each other. Fort Mojave, Fort Piute, Camp Rock Springs, Cedar Canyon, Marl Springs, and Fort Soda (Zzxyz Springs) were dotted across the Mojave and manned by U.S. soldiers in an effort to foil native attacks against Americans heading west. At one time, this desert road was used for stage and mail service between Prescott, AZ, and San Bernardino, CA. The hillock in the middle of the picture is the Jedediah Smith Butte. Padre Garces passed along here in 1776, seeking new routes to the San Gabriel Mission near Los Angeles.

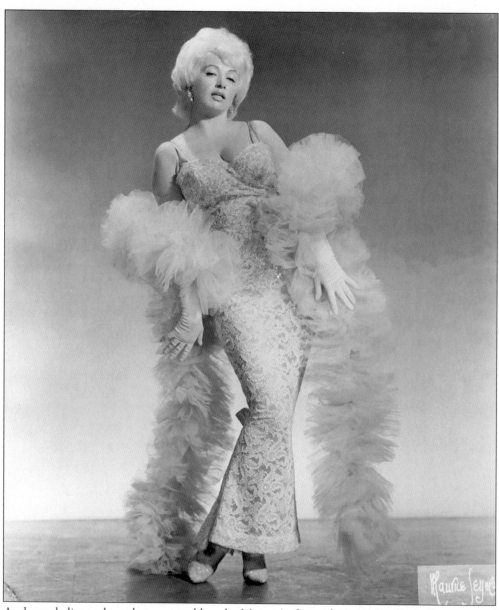

And now ladies and gentlemen, to add to the Mojave's charm, here is Miss Dixie Evans, star of the Exotic Museum in Helendale. This might actually be said somewhere in the world because various countries vie for data and news stories from the unique burlesque museum. Miss Evans began her stage life as part of a USO group. She later branched out, performing exotic dances that she said were as American as apple pie and baseball. Picking the Mojave Desert for their burlesque "art" gallery, Jenny Lee, Charles Arroyo, and Dixie converted a goat ranch into a depository of artifacts and personal items belonging to the headliners of burlesque a few years ago.

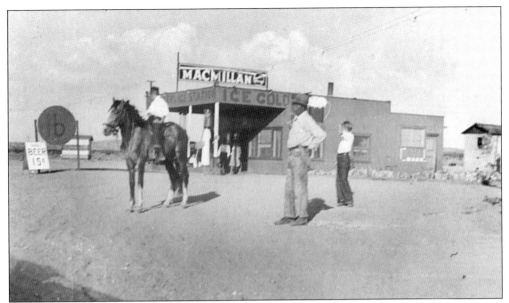

This two-pump 1932 garage in Hodge sold gasoline for 16¢ a gallon and ice cold beer for 1¢ cheaper. Riding horseback is Dudley Jay, a son of the garage owner. Note the frosty beer mug painted on the garage's side and the comfort shack (chic sales) out back. (Courtesy Henry Jay.)

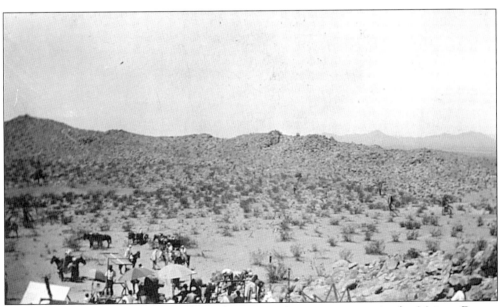

From 1920 to World War II, Hollywood movie makers were active in the Mojave Desert, filming mostly western pictures. This 1933 scene shows the Apple Valley location of a movie group, organizing for an Arab setting using Arabian costumes. (Courtesy Kraft Collection.)

Water, so vitally needed, especially on the desert, came to Interstate 40's 1972 construction crews via a pipeline. This aerial overview shows a dark line to the right of the graded area, where the temporary water pipes ran. The interstate here was approaching Needles (see arrow). (Courtesy California Division of Highways.)

Located 2.5 miles from the Nevada/California state line, Nipton, CA, is an exciting oasis, somewhat thriving way out on the Mojave. "Nippens," the name of an old American-Indian chief, became shortened to Nipton in 1910, when the railroad came through this village, which was once the crossroads of two 1880s wagon trails. The village today remains much the same and offers people a top recreational hideaway. Jack Benny (1894–1974) and E. Anderson Rochester (1905–1977), in addition to other movie and radio personalities, were often guests of Nipton's aged but still open hotel. Here, one finds a retreat to simpler times. (Courtesy Gerald Freeman—Nipton's owner.)

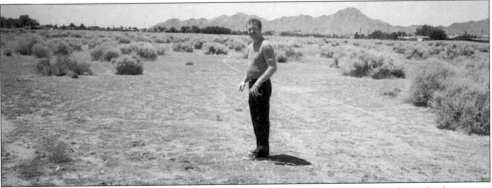

Coming from Kentucky in 1991, Harris Overholt visited Apple Valley searching for his roots. His father, c. 1916, homesteaded a piece of land near today's Zumi and Navajo Roads. There he built a cabin, dug a water well, and set out fruit trees. Dry farming proved a failure, and after several years, Harris' father moved on. Hearing tall tales about an old family ranch in Victor Valley, Overholt came west. The exact location where his people homesteaded proved interesting to Harris, for the land is still not used. The hand-dug well still peeks upward and is surrounded by aged, weathered wood. Like his father, Harris, too, moved on.

This is where the Mojave River truly runs out of water. These off-roaders have gathered at "the Sink," watching the Mojave River fade away into desert sands. Filmed in 1988, the off-roaders had just traveled from Fort Mojave (near Needles) and stopped here in the Afton Canyon region. The railroad bridge was owned by the Union Pacific Railroad Company.

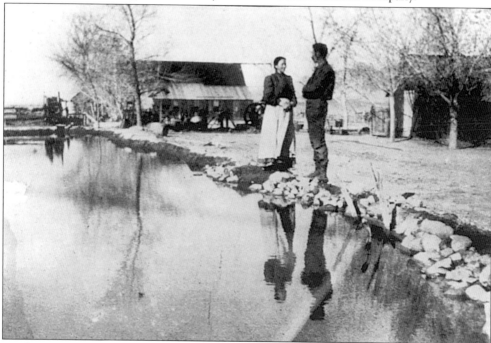

"Dad" and Mrs. Goulding, ranchers from Lucerne Valley, are seen here on their oasis property, the "Box 'S' Ranch." The Gouldings were popular people whose interest and love for the Mojave touched much that they did. Dad was especially civic-minded and greatly respected. (Courtesy *Kingdom of the Sun*.)

San Bernadino County is larger than New Jersey, Delaware, Massachusetts, and Rhode Island put together. (Map courtesy of Helena G. Allen, editor of the 1974 *San Bernadino County Museum Commemorative Edition*, and artist Mimi Ide.)

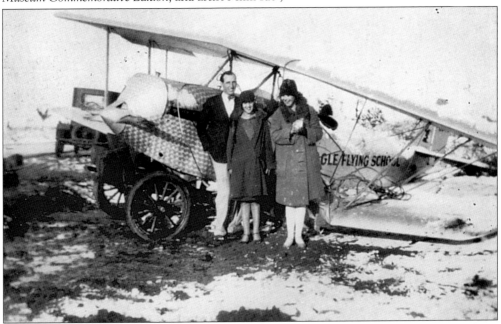

In 1928, Victorville boasted having an airport near today's Pebble Beach area. These flying machines faltered at times and often crashed on the outskirts of Victorville, way out by the county fair grounds. This Eagle Flying School aircraft decided to touch down where the Green Tree Hotel sits today. The large wheels belong to a trailer being used to haul the broken airplane away. No known injuries were reported. Posing by the downed "bird" were Clifton and Geraldine Nay and Barbara Starasta. (Courtesy Nay Family.)

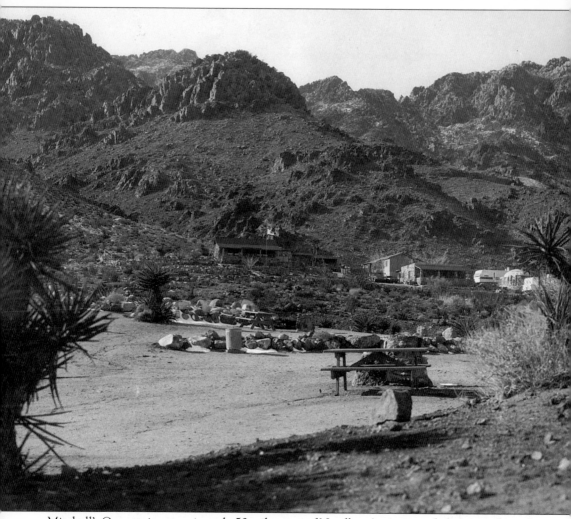

Mitchell's Caverns is approximately 50 miles west of Needles. An improved alignment from the Essex Road interchange has eased travel in this vicinity. Situated deep down in the Providence Mountains (seen here in all their glory), the state park service has regular guided tours available.

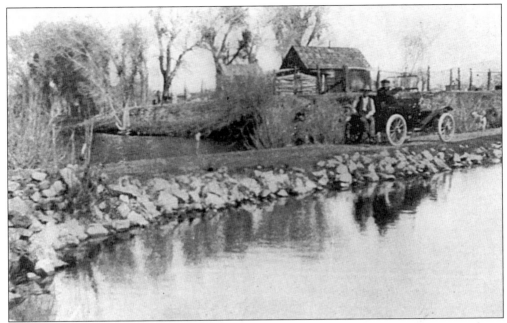

As scenes go, this c. 1910 photograph appears strange for having been taken at Oro Grande. In an early 1900s book, *Kingdom of the Sun*, reporters told of this Old Bennette Ranch being sold to a powerful group of cattle raisers from southern California. It is obvious that the area was blessed with ponds full of spring water. Currently, the springs are all but gone away.

These authorized workers are removing heavy granite blocks to be used as historical markers. The rocks themselves are historical, having been quarried nearly 100 years ago by laborers from Wisconsin. Removing these pieces without permission from BLM is unlawful and can result in fines and jail time.

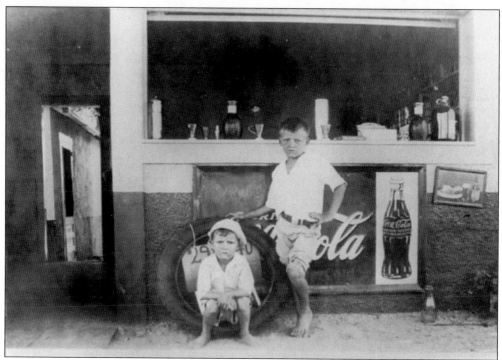

What a sight this is! Shown here in 1927 are two youngsters longing for a Coke or large orange, but they have no nickel in their ragged, cut-off jeans. Brothers Fred and George Berger are the unhappy, barefoot lads suffering through this tight situation in Oro Grande. Fred later helped to bring a fine college to Victor Valley, and he nurtured it forward with his caring leadership.

World-famous naturalist John Muir loved the Mojave Desert as much as any northern forest. This 1910 photograph shows Muir closely examining something that caught his alert eye. One of his daughters lived in Daggett for years, and her father joined her there often. Muir's death was the result of an overly long wait in freezing weather at Daggett's train station. He died in Los Angeles. (Courtesy Walter Muir.)